D0096232

MICHELANGELO: SCULPTURE

The life and work of the artist illustrated with 80 colour plates

ALESSANDRO PARRONCHI

THAMES AND HUDSON

Translated from the Italian by John Hale-White

Printed in Italy

500 41036 4

Life

Michelangelo Buonarroti was born in Caprese, a small hill town some sixty miles east of Florence, on 6 March 1475. He was the son of Lodovico di Leonardo Buonarroti Simoni and Francesca di Neri di Miniato del Sera. As a boy in Florence he was at first a pupil of the grammarian Francesco da Urbino, but at thirteen he made friends with Francesco Granacci who introduced him to the workshop of Domenico Ghirlandaio. In 1489 he was accepted into the ' Sculpture Garden ' of Lorenzo de' Medici. This was a school under the direction of the sculptor and antiquarian Bertoldo di Giovanni. He did well there, well enough to attract the admiration of Lorenzo and the friendship of the artists and men of letters of his circle.

When Lorenzo the Magnificent died on 8 April 1492, Michelangelo remained apart for a while to work on his own. Though recalled to the Palazzo Medici by Piero, Lorenzo's son, he soon left again, sensing danger in the tense political atmosphere, and fled to Venice. On his way back he found work in Bologna and stayed there some time. When he eventually returned to Florence, he found the power of the Medici overthrown and the puritan republic of Savonarola established in full vigour. He received a commission from Lorenzo di Pierfrancesco de' Medici Popolani, but soon left for Rome with the idea of recovering a work of his which had been sent there. He stayed in Rome until 1499, and there executed the first works which revealed an artistic stature beyond that of his rivals: the *Bacchus* carved for Jacopo Galli, and the *Pietà* for St Peter's.

On his return to Florence he began his *David*, and later undertook the cartoon for the *Battle of Cascina* in competition with Leonardo da Vinci, then at the peak of his powers. This cartoon in the great Council Chamber of the Palazzo Vecchio, together with the *Battle of Anghiari* which Leonardo had already begun there, was to be remembered as the ' school of the world ' by the young artists who grew to maturity during the Cinquecento.

Michelangelo was now famous, and, on the advice of Giuliano da Sangallo, Julius II summoned him to Rome. After a while the pope entrusted him with the commission for his own tomb, to be erected in the centre of the apse of the old St Peter's. At last Michelangelo found the scope to express himself with complete freedom, and to realize his ambitious dream of a single monument which would express all his ideas in a synthesis of incomparable grandeur. But the jealousy of other artists, and especially of Bramante, made the pope change his mind. The sculptor's patience was sorely tried. Finally, in indignation, he decided to leave Rome, and by the time the papal messengers had caught him up he was already on Florentine territory; it was a defiant gesture, but from then on he had to learn to make concessions. He was reconciled with Julius II at Bologna in 1506, and, while there, cast a bronze statue of the pope, before rejoining him in Rome. His friend Giuliano da Sangallo had meanwhile convinced Julius that Michelangelo should be set to decorate the vault of the Sistine Chapel. Though he had little liking for this enormous undertaking, the artist made up his mind to accept, and for four years he lived withdrawn from the rest of the world, creating his immortal visions of biblical legend. When the frescoes were unveiled in October 1512, everyone acknowledged the magnitude of his achievement.

From then on Michelangelo had plenty of commissions, but there were also long gaps and periods of intense meditation. Above all, through the experience of the *David* and the Sistine ceiling, his humanism matured into a full and perfect formal consciousness. He appeared as *il divino*, the idol of the younger generation, the genius who had brought to fulfilment the two and a half glorious centuries in which the art of Tuscany seemed to surpass the splendours of the antique. But he did not enjoy his success; his life, as revealed in his letters, was continually preoccupied with helping his family, and he himself remained a solitary and frustrated figure, always in search of perfection. His thwarted sensuality fed a vein of poetry which, in a century of Petrarchan influence, looked back to the more intimate, rough and colloquial poetry of the Florentine Quattrocento.

In his sonnets he arrived at a sublimation of the senses, already prefigured in the neoplatonism of Ficino, but strengthened through profound contemplation. It was the fruit of a spirituality which, in its desperate sense of guilt, belonged to the age which opened with Savonarola and led on to the Reformation.

Meanwhile the tomb of Julius II, who died in 1513, still called for completion. But the election of two Medici popes, Leo X (1513-21) and, after a two-year interval, Clement VII (1523-34), put every obstacle in its path. The project dragged on and, after 1523 at any rate, became for him such a source of frustration that he referred to it as 'the tragedy of the tomb.' A commission from Leo X for the façade of San Lorenzo in Florence was also taken up with enthusiasm, only to be suddenly dropped. But the election of Clement VII coincided with a happy and productive period, and work on the Medici Chapel and the Laurentian Library, which had started in 1519, continued uninterrupted until 1526. It was resumed again in 1530, and finally abandoned in 1534, in a state which fortunately reveals the general outline of the work.

During this period Florence was involved in war, and, after the siege of 1530, fell again under the rule of the Medici. Michelangelo had fought for the republic and for the freedom of his city, but, being a great artist, he was accepted by the new régime without loss to his material status or to his unique prestige. In spite of this, in 1534 he left Florence under the tyranny of Duke Alessandro de' Medici, never to return again.

In 1535, after a year in Rome, he was appointed by Pope Paul III (1534-49) to paint the *Last Judgment*. Once again Michelangelo accepted against his will a painting commission in the Sistine Chapel, but he did so in the conviction that he was the only person able to complete the theme which he had begun in the frescoes of the vault. In these he had shown the creation of the world; now, on the wall behind the altar, he painted the end of man's existence, the *Last Judgment*. This he finished in 1541. In it we see for the first time that tragic invocation of divine justice which was born with the Reformation. While the

ceiling frescoes had been an unconditional success, the new work disconcerted as much as it excited enthusiasm, for it transgressed the limits traditionally imposed on art in its portrayal of sacred themes.

His work continued between 1542 and 1550 with the two frescoes for the Pauline Chapel, and, in 1545, he at last completed, on a reduced scale, the tomb of Julius II, which was erected in the church of San Pietro in Vincoli.

Though Michelangelo was now an old man, there was no hint of decline in his powers. Among the unfinished projects of this period there remain two *Pietàs*, one of which is believed to have been intended for his own tomb. His reply (in 1549) to Varchi's questions on the relative importance of painting and sculpture is wise and practical rather than theoretical and dogmatic – in contrast to the answers of seven other living artists. After 1546, the year in which Antonio Sangallo the Younger died, his personality as an architect affirmed itself more decisively. He began to formulate with extraordinary freedom the language of what was to become the revolution of the baroque against the classical. Meanwhile the first generation of mannerists had already dissipated its energies, reducing his great formal inventions to stylish trifles. A new generation of artists was rising with the spirit of the Counter-Reformation, and for them Michelangelo, his roots firmly planted in the previous century, spoke a language of the past.

He was still active and still to be seen at the court of the popes: Julius III (1550-5), under whose pontificate, in 1550, the *Lives* of Vasari appeared, and, three years later, Condivi's *Life of Michelangelo*; Paul IV (1555-9), who disapproved of him for his religious unorthodoxy as much as for his art; and Pius IV (1559-65) who gave him further architectural commissions. He was carving his last *Pietà* only six days before he died, on 18 February 1564. On 14 July, Benedetto Varchi read his funeral oration at the solemn memorial service held in San Lorenzo in Florence. Those who heard it had the impression of retracing, in the life story of this one man, seventy-five years of the history of art.

Works

What is it that makes even the earliest of Michelangelo's works stand out from those of his contemporaries? His sculptures approach the perfection of the antique; in them, wrote Vasari, there is ' a foundation more coherent, a grace more fully graceful and a perfection more absolute, carried through with effort, but with such an ease of technique that it is impossible ever to see better '. The works of Michelangelo are above all more intensely experienced, and communicate that experience more completely, than those of any artist before him. With his insistence on the self-sufficiency, the near-divinity, of the senses, Michelangelo inspired in those around him an almost superhuman exaltation. This insistence implied a break with every rule and every preconception. True, the sensibilities of the late Quattrocento could not be content with less than perfection of finish. But when it was seen how the boy Michelangelo could treat the subject of the *Battle of the Centaurs (pls 2-3)*, how that knot of struggling bodies moved with an orgiastic freedom, transforming the battle into a voluptuous revel, it was clear that a new age and a new sensibility had been born. Soon his contemporaries came to prefer that he should leave his work in the unfinished state, with its suggestion of a multiplicity of meanings, rather than define in it one meaning only.

Michelangelo was undoubtedly a dreamer, and, like all dreamers, afraid of the awakening into a harsh and well-defined reality; nonetheless, he knew how to act when the moment came, and how to marshal · the images of his dreams. From the beginning he had also a mature sense of suffering, understood as expiation, the inevitable punishment of man. Matured by the conventions of a Christian upbringing and deepened during the years of Savonarola's preaching, this sense became for him the constant recourse of conscience and of introspection. It is the salt in the pagan nectar, filling his images of happiness with a sense of ineluctable fate.

7

One factor which developed Michelangelo's sense that man's destiny lay in suffering was undoubtedly his practice of anatomical dissection at the early age of eighteen. He was probably the first artist to have had so complete an opportunity, and he undertook this daunting task with an almost religious zeal. It enabled him to master rapidly the complicated structure of the human body and gave him the ability to represent it with a variety and freedom never before attained. It also brought him face to face with the reality of death.

A period of formation is essential for every artist, whether he is one whose experience develops steadily in one direction only, or one who needs to find himself through a variety of experiments. In which of the two categories should we place Michelangelo? It has been customary to consider only six sculptures as representing his activity before the *Pietà* in St Peter's: the two reliefs of the Casa Buonarroti, the *Virgin of the Stairs (pl. 15)* and the *Battle of the Centaurs (pls 2-3)*; the three small figures for the *Tomb of St Dominic (pls 11-14)*, and the *Bacchus (pls 31-6)*. At least six other works mentioned in our sources have been presumed lost: the *Faun*, the *Crucifix*, the *Hercules*, the *Young St John*, the *Cupid*, and the *Sleeping Cupid*. This has led us to overlook the very notion of experimental variety in Michelangelo's formative years. Of the works generally accepted as extant, only the *Battle of the Centaurs* shows him approaching the style which he was to develop at the beginning of the Cinquecento. The relief of the *Virgin of the Stairs* is an essay in the 'flattened' relief of Donatello, and the three statues for the *Tomb of St Dominic* are limited in theme by the obligations of the commission. Thus the *Bacchus*, the first work of any size which we have, appears almost unexplained, and for this reason was long taken to be a work of antique inspiration.

Of the six sculptures of his youth and the two bronzes of his early maturity, *David* and *Julius II*, all of which are generally supposed to be missing, only one can be considered as indubitably lost: the statue of *Julius II*, executed between 1506 and 1508, and destroyed in 1511 on the

8

return to Bologna of the House of Bentivoglio. I suggest that almost all the others are in fact extant.

Michelangelo's lost *Head of a faun* is probably the restored part of the Hellenistic ' *Red Marsyas* ' in the Uffizi (*pl. 1*). The wooden *Crucifix* we can identify as that in the church of San Rocco at Massa (*pls 4-10*). The *Young St John* is to be found in the Bargello in Florence (*pls 16-23*). The *Sleeping Cupid* is probably to be identified with the theme of the Hellenistic *Hermaphrodite*, all the versions of which should now be studied, with particular attention to the one in the Louvre (see p. 32). The other *Cupid* has come to light recently in a private collection, though unhappily only as a fragment (*pls 25-9*). We can recognize a model for the bronze *David* in a small bronze in the Museo di Capodimonte in Naples, which has not hitherto been attributed with certainty to any artist (*pl. 44*). To the list of works recorded in the sources, we can probably add a *Venus* (*pl. 4*), first attributed to Michelangelo by Marangoni, and a fragmentary *Apollo*, which was once in the Bardini collection, though its present whereabouts is unknown (*pl. 30*).

The loss of the correct attribution can be explained for nearly all these works. The *Head of a faun*, a very youthful work of restoration, probably no longer satisfied the mature artist. The two biographers, Condivi and Vasari, mention it, without giving its location, presumably in order to preserve the anecdote of the admiration Lorenzo the Magnificent showed for this work. The *Crucifix* disappeared from Santo Spirito, doubtless in some illegal fashion, before 1607, the date of the consecration of the new high altar where it was due to be reinstated. Dr Margrit Lisner's recent discovery, in Santo Spirito itself, of a wooden crucifix which she seeks to identify as the youthful work of Michelangelo, gains its wide acceptance from the place in which it was found; but the careful seventeenth-century accounts of the monastery make no further mention of a sculpture by him, and one cannot imagine it to have been suddenly forgotten. In fact, after its disappearance at the beginning of the seventeenth century, we can recognize it again in the crucifix which appears a little later

and further afield at Massa. It was left under the will of the sculptor Felice Palma, in 1625, to a monk, who in turn gave it to the church of San Rocco. There it was described by Baldinucci as a ' *meravigliosa figura* ' and attributed to Palma. Recent cleaning has uncovered the painted surface in fairly good condition, and allows us to see in this brilliant study the first application of Michelangelo's new anatomical knowledge. The explanation of the loss of the winged *Cupid* is simply that, being so small, it was forgotten in the course of four and a half centuries. The same applies to the *Apollo*, not mentioned in the sources but seen by Ulisse Aldovrandi in the garden of the house of Galli in 1556, and to the *Venus* now in the Casa Buonarroti (*pl. 4*).

With two further statues, on the other hand, the explanation is a matter of stylistic misunderstanding: an old mistake in the case of the *Young St John* in the Bargello, and a more recent one in that of the small bronze *David*, acquired by the Naples museum in 1898. I have gone into this in more detail in the notes on the plates.

It is clear that these two works have something fundamental in common which does not correspond with the generally recognized style of Michelangelo. Both figures sway out from their centre of gravity as if they still shared Pollaiuolo's obsession with the force of energy; in the case of the *David* this energy is dynamic and carefree, whereas in the *Young St John* it is introverted and almost painful; both are, however, profoundly serious interpretations. They have been excluded from the traditional canon of Michelangelo's works, probably because they still show the characteristic naturalism of the Quattrocento and lack the noble grandeur of his more celebrated works. More than any other of his sculptures the *Young St John* would seem to support Vincenzo Borghini's statement that Michelangelo worked in the style of Donatello; but to attribute the work to Donatello is to go too far. The *Crucifix* of San Rocco, Massa, does have the noble grandeur characteristic of Michelangelo; but, being in such an obscure situation, it has had to wait till now to be recognized as his work. Condivi recounts that Michelangelo's *Crucifix* was ' little less than

life-size ', and Baldinucci, speaking of the *Crucifix* at Massa as though it were the work of Palma, says also that it is ' almost as large as life'. In fact, in its slightly flexed position it measures 5 ft 4 in. from the top of the head to the point of the left heel. The strong resistance to the attribution to Michelangelo has led to its being considered as belonging to the circle of Giambologna, and it is true that the great bronze crucifixes of Giambologna resemble it closely enough. But in relation to them, this one should be seen as a prototype, rather than as a derivative; and it should be viewed in the same light in the context of Michelangelo's works.

While these works were considered lost, it is understandable that the *Bacchus*, the first work in which the artist competed successfully with the antique, appeared to be without explanation. But now we can understand the transition from the *Young St John* to the *Bacchus* by reference to the *Cupid* and the *Apollo*. These two permit us to see how the harshness of the earlier forms gradually matured into the delicacy and poise of the *Bacchus* and, later, of the Christ of the *Pietà* in St Peter's.

One can truly speak of a conspiracy of history to conceal the youthful activity of this most famous of sculptors. To some extent, as we have hinted, the responsibility lies with Michelangelo himself, who may well later have been dissatisfied with certain works, notably the *Head of a faun*. In regarding the relief of the *Battle of the Centaurs* as the best proof of his natural destiny for sculpture, Michelangelo presumably had in mind·its foreshadowing of the atmospheric freedom, and conscious lack of finish, which later become his personal means of expression. It would be understandable if he wished at the same time to draw a veil over the other works of his youth, with their conventional high finish.

Posterity was unconsciously to support this judgment by attributing the *Young St John* to Donatello or to Francesco di Giorgio Martini. So, in time, the youthful works of Michelangelo were sifted out to leave only those which possess the central dramatic element, and show him searching for the means to express his unique sense of superhuman

grandeur. This sense was innate; but, unless we are to believe that Michelangelo's style was born fully formed, it can have attained its full expressive power only after many trials.

The first subject to which he applied himself was the *Head of a faun*, which he had to copy from a much-damaged antique marble, and which I identify with the restored part of the so-called *Red Marsyas* in the Uffizi (*pl. 1*). The marble in which this antique is carved is in fact Greek, and not red at all; it might therefore be identical with the 'white' *Marsyas*, noted by Vasari at the entrance to the garden of the Palazzo Medici, the restoration of which he attributed to Donatello. The restored part, from the chest upward, is carved in white Carrara marble, and one cannot say that, in general, it is very satisfactory. But the head itself is an expressive piece of carving, still tied though it is to Verrocchio's preoccupation with 'atmospheric' surface values. It corresponds less to conventional representations of Marsyas than to Vasari's description of a faun: 'old, antic and wrinkled, with broken nose and laughing mouth'.

It is with this untamed and bestial image, which stirs our imagination of the mythical beginnings of man, that Michelangelo begins his long dialogue with the antique.

After the *Head of a faun* came another treatment of the mythological theme of the man-animal, suggested to him by Poliziano: the *Battle of the Centaurs* (*pl. 2-3*). In this theme of violent struggle Michelangelo found a subject with which he could set out to emulate, not only the urns and sarcophagi of antiquity, but also the pulpit reliefs of Nicola and Giovanni Pisano. These he had probably already seen at Pisa, Siena or Pistoia, and they represented for him, as for Brunelleschi a century before, the beginning of modern sculpture. Neither Antonio Pollaiuolo, in his famous engraving of ten nude figures fighting, nor Bertoldo di Giovanni, in his magnificent bronze relief in the Bargello, managed to escape the constriction of precisely defined outlines, but Michelangelo, by leaving his work in an unfinished state, gave it an airy freedom, almost as if he were re-creating in relief the atmospheric perspective of the paintings of Masaccio. It was the first time this had been

achieved in a relief; that is to say it was probably the first time anyone had admitted that a roughly finished work could be improved no further by polishing the surface.

Michelangelo's career as a sculptor had a good start with this relief but straight away the death of Lorenzo de' Medici left him in difficulties. The Palazzo Medici was in a state of crisis and he returned home to work alone on a larger than life-size figure of *Hercules*. This passed into the possession of the Strozzi family and stood in the courtyard of their palace. At the time of the siege of Florence, it was sent by Giovan Battista della Palla to Francis I, who had it placed in the Jardin de l'Etang at Fontainebleau. In 1713 it was taken away from there, and since then we have no further records. It would be interesting to know whether Michelangelo had already had the time to incorporate in his *Hercules* the results of his anatomical studies, but Condivi's account seems to leave no doubt that he began these researches at a later date. It therefore seems more likely that the *Hercules*, along with the *Venus*, (*pl. 4*), which Marangoni assigns to the Sagrestia Nuova period and Tolnay to the first stay in Rome, represented the final result of his first contact with the works of antiquity in the ' Sculpture Garden '.

The *Crucifix* (*pls 5-10*) on the other hand, was Michelangelo's first religious work, and the result of an experience which must have been decisive for the young artist. It is his only work in wood which the sources mention, and he gave it to Niccolò Bicchiellini, the Prior of Santo Spirito, in gratitude for having been allowed to do his anatomical researches in the hospital of the monastery. The wood must have lent itself more easily than marble to working out the results of his new and intensive studies.

Anatomy was the new science of the moment. At the age of eighteen Michelangelo, through the friendship of a priest, was able to immerse himself in a repugnant task, which only strength of will and reason could render supportable, that of dissection. He explored in depth all the workings of the human machine. From then on he was its master, and could, as Delacroix pointed out, treat each member in its own right, independently of the function it assumes in a

given action. Thus for Michelangelo the concept of action becomes independent of the practical purpose of any particular act, and only rejoins it in exceptional situations; hence the *contrapposto* of his figures (or ' *serpentinato* ' as Lomazzo called it), which makes their action complete within itself, rather than directed to an outside function. In his *Crucifix* the body moves through subtle counterpoints and, rising against gravity, culminates in the weight of the head which hangs in an attitude of supreme abandon. The young and heroic character of the Christ we find again, though softened, in the *Risen Christ (pl. 58)* in Santa Maria sopra Minerva, and it was later taken up by Cellini and more especially by Giambologna. The *Crucifix* therefore gives us the prototype of what we can from henceforth call the Michelangelo ' hero '.

He had hardly finished it when he was recalled to the Palazzo Medici by Piero di Lorenzo. There he must have felt the clash between the corruption and loose behaviour of the new Medici circle and the ideals of Christian regeneration which were being preached by Savonarola. Conscious of impending disaster, he left for Venice and subsequently established himself in Bologna, where, through the influence of a friend, Gianfrancesco Aldovrandi, he was given a commission of some difficulty. It involved carving the four small figures still lacking for the tomb of St Dominic, which Niccolò dell'Arca had left unfinished at his death some few months before. Only twice in his life did Michelangelo have to work on schemes not entirely of his own conception: this tomb and the Piccolomini altar in Siena Cathedral. In the case of the tomb he was particularly limited as to size: about 60 cm. (24 in.) for the two *Saints* and 55 cm. (20 in.) for the *Angel*. But, in spite of the scale, and the fact that the *St Petronius* had probably already been blocked out by Niccolò, the powerful personality of Michelangelo revealed itself straight away.

In Bologna Michelangelo was struck by the tragic and contorted paintings of the Ferraran Quattrocento. Also, and above all, the sculpture of Niccolò dell'Arca, the *Pietà* in Santa Maria della Vita and the tomb of St Dominic to which Michelangelo had to adapt his own work, must have

impressed him by their ability to express emotion. The most personal of Michelangelo's own figures, the *Angel holding a candlestick (pl. 14),* has a virile, Olympian calm and a solemn aloofness which contrasts with the fragile beauty and modesty of its companion by Niccolò. The *St Petronius (pl. 11)* is probably less surely handled because it had already been blocked out, as we believe, by the older sculptor. But the *St Proculus (pls 12-13)* is highly expressive, in spite of having been broken into more than fifty pieces in 1572. There is a threat of violence in that furrowed brow and piercing glance, the taut skin on the hand raised to the chest and the pent-up spring in that careful step.

By the end of 1495 Michelangelo was back in Florence, and the *Virgin of the Stairs (pl. 15),* which has traditionally been considered to be the artist's earliest work, may in fact be the result of a private commission of this time. It would appear to belong to a moment of looking back, as it adopts the so-called 'flattened' relief of Donatello and yet, at the same time, seems to refer in several points to the thirteenth-century reliefs of the tomb of St Dominic which Michelangelo had just completed.

On his return home, Michelangelo enthusiastically subscribed to the ideals of Savonarola, which were then in the heyday of their success. His nature, still that of a twenty-year-old inspired by the attraction of opposites, now showed its first proofs of true genius, for it was in the spirit of Savonarola that he created his *Young St John* for Lorenzo di Pierfrancesco, who belonged to the branch of the Medici family known as the Popolani. This figure was long believed lost, and has been identified with various other works, but I recognize it in the *Young St John* of the Bargello (*pls 16-23*). Since the seventeenth century this had been assumed to be the work of Donatello, though Cicognara had suspected that it might be rather later. Kauffmann subsequently recognized in it the influence of Michelangelo but, inexplicably, sought too far afield and attributed it to the circle of Francesco da Sangallo. In fact, the youthful personality of Michelangelo is very clearly present in it. The lean, athletic figure of the young saint advances with his eyes fixed on the scroll which he holds in his left hand, and the summary

treatment of the camel-skin is in conscious contrast to the brilliant anatomical skill of the uncovered parts of his body. The statue is carved from a long, narrow block and leans to the limits of equilibrium, thus foreshadowing the bronze *David* and, at the end of his life, the *Rondanini Pietà*. The restitution of this problematical work to Michelangelo's *œuvre* throws more light on the meaning of his early activity. So long as several works mentioned in the sources remained unidentified, we could think of him as already immersed in some magnificent dream of his future achievements, but, as soon as we rediscover some of them, we can see the artist feeling his way from work to work in a logical progression.

The titles of the subjects which he attempted in his early years suggest that the artist chose them for their contrasting themes. After the *Young St John* he carved a *Sleeping Cupid* which has also been considered lost. It has always been believed that this sculpture represented a baby cupid with wings. But Condivi said that it showed a boy of six or seven. As it was probably a version of an antique marble, was it perhaps a copy of one of the Hellenistic Hermaphrodites (see p. 32)?

Michelangelo's *Sleeping Cupid* had a curious history; it was probably thought wise to send it away from the Florence of Savonarola because of its erotic character, and, on the advice of Lorenzo di Pierfrancesco, it was aged with patina and sent to Rome. There the Cardinal Raffaello Riario acquired it as an antique, but when he realized it was modern, he demanded his money back. Michelangelo went to Rome to try to recover it, but did not succeed.

His journey to Rome, apart from this practical purpose, must also have had the more idealistic one of discovering the finest masterpieces of antiquity. He immersed himself in classical art, and his own work gained from it a concentration and a plenitude which it had lacked before. Cardinal Riario, whose guest he was, commissioned a 'figure from life', now lost. Then, on 19 August 1497, Michelangelo wrote to his father that he had begun to work on his own account. His first sculpture in Rome was the *Cupid* which has recently come to light, though sadly damaged (*pls 25-9*). The

little figure is carved in a block of Greek marble, the natural size of a boy of four, and it reveals a mastery of space unequalled since antiquity. The surface is for the first time like living flesh; the ecstatic movement is irresistible. Dynamism has here overcome the gracefulness of the Quattrocento, and this development was to continue, though sluggishly and inconsistently, through the art of the Cinquecento until it erupted again in that of the baroque.

It was probably directly after the *Cupid*, and before the *Bacchus*, that Michelangelo decided to carve an *Apollo* for Piero de' Medici, who was leading a dissipated life in Rome while dreaming of his return to Florence. This *Apollo* is in my opinion identical with the fragment which was sold in London, at Christie's, at the beginning of this century, but whose location is no longer known; from the photograph in the sale catalogue (*pl. 30*) we can guess that it represented a transition between the *Cupid* and the *Bacchus*.

The *Bacchus* (*pls 31-4*) was carved for Jacopo Galli, a rich banker and gentleman of culture, who had understood the brilliant possibilities of the young artist and decided to encourage him in every way. He acquired the *Cupid* and the *Apollo* which had been made independently, but the *Bacchus* he commissioned personally. In this work Michelangelo approached a well-known classical theme, that of the god of wine attended by a satyr, but freed himself from its constrictions with a completely original solution. He gave the god the slim but flaccid body of a young drunkard, his head crowned with vine-leaves, who advances with shaky step, a goblet in his right hand, and in his left a bunch of grapes which the little, grinning satyr plucks at from behind. In spite of the classical inspiration, everything about this figure seems new: its complex planes are subtly articulated and marvellously smooth, and this impression is due above all to the apparently unstable stance, which shows a mastery of form such as no sculptor had possessed before.

Rome had matured the youthful prodigy. From now on the art of Michelangelo, for all the rich variety of its themes, takes on an extraordinary unity of character. The modern ideal meets the classical, and between the two poles there is a feeling of freedom and a powerful breath of life.

17

The *Pietà* *(pls 37-41)* closed this brief but intense period devoted entirely to the spirit of the antique. Its commissioning by Cardinal Jean Bilhères de Lagraulas represented a return to the religious themes which he had not touched since the *Young St John*. Direct contact with the antiquities of Rome had greatly broadened his powers of expression, and certain friends, who understood the significance of these powers, now sought to direct them into more spiritual channels. We should remember that it was at this time that the political ascendancy of Savonarola in Florence was drawing to its tragic end, and that this man represented for Michelangelo the symbol of his inner conflict. He must have realized, during his first years in Florence, what a problem Savonarola's teaching would present to his own strong sensuality, and yet, as with all his generation, he could not escape the fascination of its authority. All his life, that voice would haunt him with its call to a higher spiritual reality and to a total moral commitment; it would determine the notes of bitter remorse in his poetry, and the deep preoccupation with tragedy of his old age. Under Savonarola, Florence had felt a vocation as the centre for the moral regeneration of the world, and when the news came of his death at the stake in 1498, it must have affected Michelangelo as an irrevocable turning point of destiny.

Before the *Pietà* he had worked mostly for the refined tastes of private collectors. With the *Pietà*, he worked in the knowledge that it would be placed in St Peter's, in the chapel of the kings of France. When it was shown, to the admiration of all, he heard people attribute it to a more famous sculptor of the time, and, realizing how little his name was yet known, he carved it on the ribbon across the breast of the Virgin.

In the *Pietà*, the sculptor set himself a most ambitious task, and admiration for its sheer audacity has to some extent impeded the proper understanding of the sculpture. The complicated folds of the Virgin's robe form a rich background to the body of Christ, and are carried out lovingly to the smallest nuance of detail. The strong naturalistic element is nonetheless subordinate to the formal design of the sculpture and to the depth of feeling expressed in it.

This feeling is extremely intense, for, though full of the exalted spirit of classical antiquity, Michelangelo now discovered in himself an infinite capacity for response to suffering.

The work was an immediate success, but from the beginning people tried to counter this with criticisms of its representational correctness; they complained that the Virgin was far too young. The artist silenced his critics by explaining that he had wanted to represent the Virgin with the perfection of a body untouched by sin.

At the turn of the new century Michelangelo returned to Florence crowned with the laurels of this success. He brought with him a commission for fifteen small statues for the Piccolomini chapel in Siena Cathedral (*pls 42-3*). Of these he finished a *Virgin and Child* (*pl. 42*) which perhaps surpasses even the *Pietà* in the expressive intensity of its tall, narrow, proportions; the Madonna appears as a young girl absorbed in the thought of her divine destiny. He also began work on four of the other figures of saints, but in 1503 he was released from the urgency of this obligation by the death of Pius III, who as Cardinal Todeschini-Piccolomini had given him the commission, and for its completion he turned to a sculptor friend, Baccio di Montelupo, who was to remain faithful to him all his life.

He was primarily interested in the orders of his own fellow-citizens, and he had received one of a kind to give full scope to the unbounded confidence which he now possessed. The administration of Florence Cathedral had assigned to him a giant block of marble which everyone had considered unusable, since an earlier sculptor had already begun to carve it. Having obtained it for himself, Michelangelo found the opportunity to demonstrate freely his own conception of sculpture, and produced from this ruined block a perfect figure of *David* which is over fourteen feet high (*pls 45-6*).

While working on it he accepted only one other commission. This was for another, and complementary, figure of *David* in bronze for Pierre de Rohan, Maréchal de Gié, who wanted a statue similar to the bronze *David* of Donatello. In the course of modelling the clay for it the sculptor

probably worked out the details of the giant marble. A small sketch model in bronze for this second *David*, with something of the same spirit as the *Young St John*, is to be found in the Capodimonte Museum in Naples (*pl. 44*). It formerly belonged to the Farnese collection, and passed to the museum in 1898, where it was attributed first to Pollaiuolo and then to Francesco di Giorgio Martini.

It is important to understand how Michelangelo's return to Florence revived his feeling of civic pride and involvement, just as it had when he came back from Bologna some years earlier. Now that Savonarola was gone, the republic of Florence lived through a period of muted glory under the *Gonfaloniere* Soderini, but there is no doubt that the absence of the Medici gave the city the air of freedom which it had lacked for so long, and the illusion of recapturing the atmosphere of that period, eighty years before, which had been the happiest in its history. If the political situation was insecure, the work of the artists appeared at last to bear the fruit of two centuries of astonishing development.

Michelangelo's works of this period are the highest expression of the new climate. The cartoon of the *Battle of Cascina* which, together with Leonardo's *Battle of Anghiari*, was to decorate the great Council Chamber, celebrated the military prowess of the Republic. The marble *David* (*pls 45-6*), which was completed in two and a half years, symbolized the triumph of the republican liberties. When we see it we are amazed that a man of thirty could have achieved so immediately what the sculptors of antiquity had attempted in vain: a statue much bigger than life which does not oppress as a monstrous abnormality. Michelangelo overcame this problem of size by portraying his *David*, as the traditional figure of an adolescent, in such a way that we feel his inherent potential of further growth. It was no part of the artist's intention to emulate classical proportions, but rather to replace them with a new beauty of expressive suggestion, and there are many disproportionate elements in the figure which are precisely those of adolescence. The huge head, its mass increased by the curly hair, the long arms and heavy hands, the

slender flanks and the excessively long legs, somehow combine to give this giant a feeling of spontaneous harmony.

With this statue Michelangelo gave overwhelming proof of his powers, and from now on he was assailed with commissions. The two *tondi*, the *Pitti Madonna* and the *Taddei Madonna* (*pls 47-8*), belong to this period. They follow a favourite theme of the Florentine Quattrocento, the Virgin and Child with St John, but with a fresh sense of composure and harmony, a firmer and happier crystallization of the image, and a richer sense of atmosphere.

Michelangelo was now called to Rome by Julius II, who commissioned him to design his tomb. This was to surpass those of all his predecessors, and was to be placed beside the throne of St Peter at the heart of the greatest temple of Christianity. The sculptor travelled to Carrara to supervise the quarrying of the marble he would need, and had it shipped to Rome, but at this point the Pope began to have second thoughts about the project. These may have been due to the intrigues of rival artists, especially Bramante, or else to a sudden scruple in the Pope's own mind lest such a gesture of self-glorification might be going too far. Michelangelo, who could think of nothing else but this stupendous project, reacted violently. Proudly sure that he could not be replaced, he did not hesitate to offend the Pope by leaving Rome in a huff. Back in Florence, and probably still in the heat of his anger, he set about carving one of the twelve apostles which had been commissioned for the Cathedral. This was the *St Matthew* (*pl. 49*), which was to remain unfinished but which is for us the most perfect demonstration of how an image liberates itself, clear and untrammelled, from its block.

The reconciliation with the Pope came about shortly afterwards, at Bologna in 1506. Julius II evidently realized that here was an artist different from the others, and that he had to come to terms with this man who dared to oppose him. First he ordered a statue of himself in bronze, larger than life. Set up on the façade of San Petronio in Bologna in 1508, it was thrown down in 1511 at the return to power of the Bentivoglio family. But Julius also came to hear of Michelangelo's reputation as a painter

after his cartoon of the *Battle of Cascina*, and when the artist rejoined him in Rome, the Pope set him to another herculean labour, the decoration of the vault of the Sistine Chapel. Having resisted as long as he could, the artist was obliged to accept, but as none of the proposed schemes would satisfy him, he was left completely free to invent his own subjects throughout. Nonetheless, during the four long years of work on the ceiling, he never abandoned the thought of the papal tomb. On the death of Julius in 1513, Michelangelo renewed the contract with his heirs, the Della Rovere family, and set to work with the intention of finishing the task as soon as possible. The next Pope, however, was an old friend, Giovanni de' Medici who took the name of Leo X, and after three years he became impatient to employ the artist for his own ends and for the glory of his family. He wanted him to build the façade of the Medici family church of San Lorenzo in Florence. Though attracted by this new project, we can imagine how the artist must have suffered at having to postpone, yet again, his work on the tomb. Another contract was drawn up for a simplified monument in 1516, but not even this was to be completed.

After the death of Leo X in 1521, and the brief pontificate of Hadrian VI (1522-3), there followed a long period of frustration over the tomb, and also, it seems, of remorse. This lasted until a fourth contract was drawn up in 1532, in which the project was further reduced to a single façade standing against the wall. In this form it was finally erected in San Pietro in Vincoli in 1545.

If we follow the development of Michelangelo's attitude to the tomb of Julius II, as revealed in his letters, we see how his determination to complete it began to weaken about 1523. Let us therefore take this date as the turning point, before which he was adding new figures to the monument, but after which he thought only of reducing the project and of employing the elements which he had already finished. We can thus assume that none of the statues of *Captives* was begun after 1523, and probably only the *Victory* was continued after that date, at the same time as the sculptures for the Medici chapel.

Before that year, however, there had been a whole series of powerful creations destined for the tomb. The *Moses* (*pls 52-3*) dates from between 1513 and 1515, and seems to have been inspired by the sculptor's anger at the destruction of his bronze figure of *Julius II* at Bologna. With its gesture of restrained and compact power, the *Moses* is the most impressive example of that *terribilità* which is the new and personal dimension of Michelangelo. It is the culmination of the great Florentine tradition, and posterity has regarded it with a special veneration. At the same time he made the two *Captives* (*pls 50-1*), now in the Louvre, the only figures which he carved for the tomb while in Rome. In the *Dying Captive* and the *Heroic Captive* the calm of the nude is infused with a unique passion. On the other hand, the four *Captives* (*pls 54-7*) which he started carving in Florence before 1519 were never developed far enough for us to appreciate anything other than the drama of these forms which struggle to free themselves from their blocks. The only work of the series which succeeded in freeing itself was the *Victory* (*pl. 59*), which will be discussed later on.

While he was in Florence in 1520-1, Michelangelo worked on his figure of the *Risen Christ* (*pl. 58*), now in the church of Santa Maria sopra Minerva in Rome. We must bear in mind that the contract for this statue dates from 1514, and that a first version had been discontinued because of a fault in the marble. The fact that Michelangelo was re-creating a work of six years before explains why this statue appears to express a concept which had been superseded by works of the intervening period. Perhaps also Michelangelo could no longer feel freshly about so traditional and symbolic a theme, after experiencing the freedom of working on his *Captives*. His *Risen Christ* is an effeminate figure, and its forms are full and soft; but these weaknesses are outweighed by the melancholy on Christ's face, as if the memory of his Passion weighed heavily upon him.

Work on the Medici Chapel began in September 1519 and the sculptures for the Medici tombs (*pls 60-4*) must have been begun a few years later. The rapid progress

of the building, and the perfect accord between the conception of the tombs and the new spirit of Michelangelo's architecture, created the best possible atmosphere for work on the statues. In these allegories of the four divisions of the day the artist expressed the inexorable passage of time. He created precise images for the vaguest and most universal feelings: the pained awakening of *Dawn* and the apprehensive looking-back of *Dusk*; the restless, sensual sleep of *Night*, and the clouded face of *Day*, showing above massive shoulders. The character of these figures, more than that of any others, appears to find its roots in the *Bacchus*. Their bodies are elongated, with full, heavy forms closely knit together, but the heads of the two male figures are left unfinished. This is an act of freedom, and, according to Vasari, a conscious means of expression. Michelangelo was the first to realize the power of the indefinite, its power to stimulate our sense of the infinite.

We find the same character in the small unfinished, *Apollo* (sometimes interpreted as a *David*), which embodies the last note of Renaissance hedonism in the work of Michelangelo (*pl. 65*). The *Victory* (*pl. 59*) is a more evolved work, which distinguishes itself from the *Captives* by its lighter elegance. A rather effeminate youth, in an affected and unconvincing pose, half kneels on the crouching figure of the vanquished. Close to the *Victory* in feeling are the figures of *Giuliano de' Medici, Duke of Nemours* and *Lorenzo de' Medici, Duke of Urbino* (*pls 68-9*). In life, these princes had hardly been heroes to excite the imagination, but such they became in the sculptures of Michelangelo, who, without any attempt at portraiture, created two classic images of *condottieri*. The last of his sculptures for the Medici chapel was the *Virgin and Child* (*pls 70-1*), which was left unfinished. The Child sits astride the Virgin's knee in an attitude taken from a relief of Jacopo della Quercia in Bologna, except that here he turns to look at his mother. It is a clear and refined image, a prelude to the last phase of the artist's development. There exists also at the Hermitage in Leningrad the figure of a *Crouching Youth* again intended for the Medici tombs, and in the Casa Buonarroti there is a model for a *River*

God (*pls 66-7*) which is treated with a vivid sense of realism.

We find this same sense of realism in the body of the Christ in the *Florentine Pietà* (*pls 72-5*). This group was already begun when Vasari's *Lives* first came out in 1550, and three years later Condivi reported that the artist thought to give it ' to some church, and to have himself buried at the foot of the altar where it would be placed'. This story has been widely accepted, as it seems to be in accord with Michelangelo's way of thinking, but it is nonetheless reasonable to doubt whether the *Pietà* can have been destined for this purpose from the beginning. If we suppose it to have been meant for a tomb, it may be that it was intended for that of one of the Medici popes, Leo X or Clement VII, in which case its beginning could be dated further back than it usually is, to the first year of the pontificate of Paul III, who was elected in October 1534. After that year Michelangelo would have had little time to give to sculpture, since in the following year he began the huge undertaking of the *Last Judgment* (1536-41). The *Florentine Pietà*, in spite of Tiberio Calcagni's disastrous re-working of the figure of the Magdalen, remains an impressive and complex achievement, the sum of brilliant intuition and deep dissatisfaction. Never did the sculptor charge his marble with a passion more intense than that which flows from this martyred body, the mother sinking under its weight, or a compassion such as that of Nicodemus, his face veiled in the mist of the undefined.

Michelangelo's works of sculpture were becoming rarer, but, after an interval, he was inspired by the murder of the tyrant Alessandro de' Medici in 1537 to carve his bust of *Brutus* (*pl. 76*). This surpasses the busts of antiquity, such as that of Caracalla, in its realistic vigour. Later on he supervised, and perhaps partly carved himself, the two figures of *Leah* and *Rachel* (*pls 77-8*), symbolizing the active and the contemplative lives, which were needed for the final version of the tomb of Julius II. This was completed by his assistants and finally set up in San Pietro in Vincoli in 1545.

Michelangelo had now arrived at his last period, which was almost barren of sculpture. Only one work of sculpture is known to have been undertaken after 1542, the *Rondanini Pietà* (*pls 79-80*). We do not know the origin of this *Pietà* either. A drawing of uncertain date in the Ashmolean Museum, Oxford, shows us what the first version must have been like, but the artist later carved away the greater part of the group in order to draw out the essence of a much purer, freer composition; according to a letter of Daniele da Volterra (11 June 1564), he was working on this six days before his death. In the final and excessively elongated composition, the nude body of Christ is still firmly of the flesh, but an infinity of ideas dwells among the roughly hewn masses.

Thus, at the end of his life, Michelangelo left a message which goes beyond perfection. In so far as we interpret this as a human act of will to try to seize the unattainable, like Prometheus, we can only see it as doomed to failure, like every other great human adventure. Nonetheless, the greatness of the man lies in his indomitable determination to express the inexpressible.

Michelangelo and the critics

For Michelangelo, possibly more than for any other artist, one can speak of a personality cult. He is the only one of the old masters who had two biographies published in his life-time: that by Vasari which forms the conclusion and climax of the *Vite dei più eccellenti pittori, scultori e architetti*, and three years later Condivi's life of Michelangelo, written with the evident intention of correcting Vasari, especially on the question of the artist's political behaviour during the siege of Florence.

From the unveiling of his *David* until his death Michelangelo was idolized by the popes, the princes and the cultured public of Italy and of Europe. He was considered by his fellow artists as *il divino*, and his difficult character was accepted with devotion by all who had to deal with him. This immense prestige made him a real power in the world, impressing on his times his own vision of life, his devotion to beauty, and his deep spirituality. All the important artists of the Cinquecento, sculptors, painters and, above all, architects, experienced the subversive violence of his art; though this influence manifested itself in the more or less debased intellectual form known as mannerism. Nonetheless, his unlimited freedom, his lack of any scruple or inhibition in expressing what he wanted, met with great opposition all through his life and this was accentuated when the Counter-Reformation imposed a puritanical obedience to the moral law. At the beginning of the seventeenth century, Michelangelo's formal inventions lent their power to the realism of Caravaggio, while his highly-charged expressiveness inspired the liberty of the baroque. This overwhelming influence faded for a while during the neoclassical period, when a different current of taste, also stemming from the Cinquecento but this time based on the ideal harmony of Raphael, was easily shocked by Michelangelo's lack of respect for the traditional canons of art. With the romantic period, however, his art began again to evoke a widespread emotional response; at the

end of the nineteenth century, but with roots going back into the eighteenth, we have the growth of the great labour of documentation and critical analysis of Michelangelo's art which produced the works of Gotti, Wölfflin, Frey, Justi, Thode, Venturi, de Tolnay, Kriegbaum, Wilde, Toesca, Panofsky, Barocchi, and many others.

One cannot say that there was ever a significant decline in the general admiration for Michelangelo. It has always been difficult to consider him without a certain aura of divinity, and the romantic story of his life has lent him a special fascination. But the works themselves, when we study them closely in the light of our knowledge of their problems, present us with an inexhaustible richness of meaning and possible interpretation.

BIBLIOGRAPHY

The starting point for any study of Michelangelo must be the biographies of Vasari and Condivi, already mentioned. For the bibliography see: E. Steinmann and R. Wittkower, *Michelangelo 1510-1926*, Leipzig 1927; with the successive additions: H. W. Schmidt, as an appendix to E. Steinmann, *Michelangelo im Spiegel seiner Zeit*, Leipzig 1930; P. Cherubelli, ' Supplemento alla Bibliografia Michelangiolesca 1931-1942 ', in *Centenario del Giudizio*, 1942, pp. 270-304; P. Barocchi and G. Vasari, *La vita di Michelangelo nelle redazioni del 1550 e del 1568*, Milan and Naples 1962, I, pp. 338-376; P. Meller, ' Aggiornamenti bibliografici ', in *Michelangelo artista pensatore scrittore*, by several writers, with a preface by M. Salmi, Novara 1965, II, pp. 597-605.

Fundamental to critical analysis are the studies of H. Thode, *Michelangelo, Kritische Untersuchungen über seine Werke*, Berlin 1908; C. de Tolnay, *Michelangelo* (five volumes so far published), Princeton 1947 onwards; P. Barocchi and G. Vasari, *La vita di Michelangelo*, Milan and Naples 1962.

For the most recent hypotheses of attribution: A. Parronchi, *Opere giovanili di Michelangelo*, Florence 1968, which includes the *Ricordanza* of G. B. Figiovanni, most useful for various interesting notes on the artist's life.

Notes on the Plates

NOTE: in this list the works newly attributed to Michelangelo are treated in greater detail than those which have been traditionally accepted.

1 'Red Marsyas', 1489-90. Marble, h. 75 cm. Florence, Uffizi. This sculpture, dating from the first century AD, underwent restoration in the late fifteenth century and the restored part may be identical with Michelangelo's lost *Head of a Faun*. The lost head is first mentioned by Condivi as having been carved when Michelangelo was about sixteen. It was identified by Richardson (1728) with a mask in the Bargello which was stolen in the last war, and by A. Venturi (1922) with a bust of Cyclops, also in the Bargello, but their attributions have never been confirmed. The recent identification with the restored part of the *Red Marsyas* in the Uffizi is based on several considerations: 1) It is known as 'red' because of certain reddish stains on the surface, though it is in fact carved in white Greek marble, and also, probably, because it was identified with a *Marsyas* in red marble mentioned by Vasari as restored by Verrocchio (ed. Milanesi, II, 366, IV, 10), which has now been lost. 2) This *Marsyas*, together with the one restored by Verrocchio, is to be seen in a drawing by Zanobi Lastricati for a panel on the catafalque at Michelangelo's funeral. It shows the young sculptor being received by Lorenzo the Magnificent at the entrance to the garden of the Palazzo Medici, and the two statues of Marsyas are on either side. We are told in the

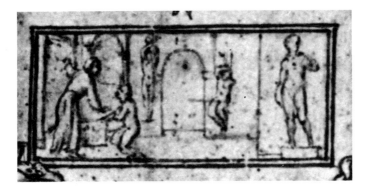

Zanobi Lastricati. Project for Michelangelo's catafalque, detail.

account of the funeral that this panel represented the 'first flowers' of the artist's work, so it would have been superfluous to include two statues with which he had no connection. 3) It is true that Vasari attributed this 'white' *Marsyas* to Donatello, but it may have been because Michelangelo was dissatisfied with this early work that Vasari did not dwell on it in the first edition of his *Lives*. 4) The restored part, in white Carrara marble, from the middle of the chest upward, with its contorted arms and hands, cannot be called a successful completion of a classical statue, and one can understand the artist not being satisfied with it later on. The head, however, shows a real vitality of expression, and an impressionistic lightness which relates it to the manner of Verrocchio. 5) The design of the head is closely similar to that of the figures of saints which Michelangelo carved for the tomb of St Dominic in 1494 (*pls 11-14*). From the garden at San Marco the statue was moved to the Uffizi in 1671.

2-3 Battle of the Centaurs, 1491-2. Marble high relief, 84.5 × 90.5 cm. Florence, Casa Buonarroti. The theme would seem to have been suggested to Michelangelo by Poliziano. It is first mentioned by Condivi, who tells us exactly when it was made: 'As soon as he had finished this work, the Magnificent Lorenzo passed from this life' (Lorenzo died in April 1492). It has never left the Casa Buonarroti.

4 Venus with two Cupids, c. 1492. Marble, h. 182 cm. Florence, Casa Buonarroti. Discovered by Guido Morozzi in the Meridiana di Pitti, it was described by Matteo Marangoni in 1958 as a work carved by Michelangelo around 1525. Herbert Keutner, in 1958, attributed it to Vincenzo Danti, but Charles de Tolnay has restored it to its rightful creator, while admitting the possibility that other artists may have had a hand in finishing it. The work itself does not, however, reveal any evidence that this was so. The quality of the 'unfinished' portions suggests a phase in Michelangelo's career very shortly after the *Battle of the Centaurs* (*pls 2-3*).

5-10 Crucifix, 1492-3. Poplar wood, almost entirely painted, h. 175 cm. Massa, San Rocco. The arms and certain small details are not original. Carved after the death of Lorenzo, it is recorded by Albertini in 1510, Vasari in 1550, Condivi in 1553 (who adds that it is 'rather less than life-size'), and also by other writers until 1600, as being above the altar of Santo Spirito in Florence. In that year the responsibility for the altar passed from the Frescobaldi family to Senator G. B. Michelozzi, who had it entirely redesigned by Giovanni Caccini. Michelangelo's *Crucifix* was meant to figure on the new altar between a statue of the Virgin and one of St John, and these statues were in fact executed, together with two figures of angels. But they were not placed in position when the altar was consecrated in 1607, and this leads us to believe that the *Crucifix* may have disappeared in the meantime. This is supported by the fact that it is not mentioned in the detailed *Memoriale* of

Santo Spirito compiled by Father Arrighi at the end of the seventeenth century. In 1747 Niccolò Gabburri wrote to Monsignor Bottari that 'one ought to say what has become of it', and in his 1760 edition of Vasari's *Lives*, Bottari mentions a *Crucifix* in Santo Spirito believed to be by Michelangelo, but says that Ignazio Hugford disapproved of the attribution. Different writers, such as Richa, record it as being in various parts of the monastery, for example the novitiate and the Barbadori altar in the sacristy, but it was eventually agreed that it must have disappeared. Thode, in 1904, thought in terms of the small Crucifix now in the choir of Santo Spirito; then, in 1961, I proposed the neglected wooden Christ in San Rocco at Massa. Since Baldinucci's reference to it, this has been traditionally attributed to Felice Palma. Baldinucci adds that it was ' almost life-size ', and recounts how, after the death of Palma, Pietro Tacca considered it to be such a prize that he was ready to pay anything to obtain it. In its powerful style it would appear to date from at least a century earlier than the worthy but not outstanding sculptor Palma, who died in 1625. In 1961, Dr Margrit Lisner discovered another Christ in Santo Spirito in which she recognized the lost Michelangelo, supposing it to have remained in the monastery all the time, unidentified and forgotten. But the style contradicts this, as also do the dimensions, 135×135 cm., much smaller than ' a little less than life-size '. (Cf. *Münchner Jahrbuch der Bildenden Kunst*, XV, 1964.)

11 St Petronius, 1494-5. Marble, h. 64 cm. Bologna, San Domenico. See note to *pl. 14.*

12-13 St Proculus, 1494-5. Marble, h. 58.5 cm. Bologna, San Domenico. See note to *pl. 14.*

14 Angel holding a candlestick, 1494-5. Marble h. 51.5 cm. Bologna, San Domenico. Together with the last two works, this was carved during Michelangelo's stay at Bologna in 1494-5 for the tomb of St Dominic, left uncompleted by Niccolò dell'Arca. The commission was obtained for him by Gianfrancesco Aldovrandi. The *St Petronius* had already been begun by the older sculptor. The *St Proculus* is mentioned by Leandro Alberti (1535) as being by Michelangelo. The *Angel*, on the right, is a pendant to that by Niccolò on the left.

15 Virgin of the Stairs, 1495-6. Marble low-relief, 55.5×40 cm. Florence, Casa Buonarròti. Mentioned by Vasari in his second edition, and almost always held to have been the artist's first work, under the influence of Donatello's reliefs. This influence is evident, but certain characteristics which refer back to Nicola Pisano, who had carved some of the reliefs for the tomb of St Dominic in the thirteenth century, place it in the period after his return from Bologna in 1495.

16-23 Young St John, 1495-6. Marble, h. 172.5 cm. including base. Florence, Museo Nazionale (Bargello). Michelangelo made a *Young*

St John for Lorenzo di Pierfrancesco de' Medici Popolani at the close of 1495. Its whereabouts is not mentioned in the sources, but several identifications have been made, by von Bode (1881), Gomez Moreno (1931), Valentiner (1938), Longhi (1958), until our present attribution (Parronchi, 1960). This *St John* is a well-known statue, listed in the Bargello since 1704, perhaps even since 1638, as a work by Donatello. Cicognara, in 1824, was the first to cast doubts on this attribution, and in 1931 Kauffmann suggested that it was derived from Michelangelo. Before that, it had been unanimously included in the catalogue of Donatello's works but, because the surface treatment was too free for him, it was frequently criticized as being of poor quality. By means of a document which Paatz summarizes, and which he connects with the lost Michelangelo, I would identify this Bargello

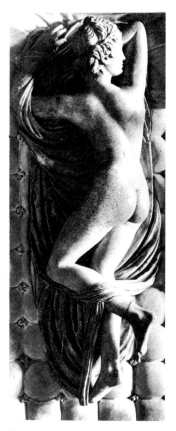

Hermaphrodite, probably the model followed by Michelangelo in his lost 'Sleeping Cupid' (see p. 33).

St John with a statue given to the convent of Santa Croce by the Duke Alessandro, and removed from there illegally at the instigation of Paolo Giordano Orsini at some time in the 1560s. In this case it would never have left Florence, but would have lost its real attribution in the course of changes in critical attitudes. The treatment of the subject shows a feeling for the story, and the young figure overflows with energy. It is the finest example of Michelangelo's efforts to imitate Donatello, and offers proof of the experimental attitude of his early period.

Hermaphrodite (black and white illustration on p. 32). Hellenistic sculpture. Carrara marble, 1. 148 cm. Paris, Louvre. This ancient work was probably the pattern of the lost *Sleeping Cupid* carved by Michelangelo in 1495-6. This was certainly a copy of a classical model. Condivi said it represented ' a boy of six to seven years '.

24 Cupid, 1497. Marble, fragment. Whereabouts unknown. See note to *pls 25-9*.

25-9 Cupid, 1497. Greek marble, fragment, h. 56.5 cm. Switzerland, Private collection. Michelangelo wrote to his father that he had begun a figure on his own account, thought to have been a second *Cupid*. It entered the collection of his patron, Jacopo Galli, where it was recorded by Condivi and Vasari, but was soon lost sight of. The old attempt to identify it with a statue in the Victoria and Albert Museum, London, was finally refuted by Pope-Hennessy in 1956. Valentiner thought it might be the *Apollo-David* of the Bargello.
It has been suggested that the fragment which I propose to identify with the 1497 *Cupid* (*pls 25-9*) originally formed one of a pair, carved for some ornamental purpose; and a photograph which recently came to my attention, of a winged, headless *Cupid* (*pl. 24*), formerly in the Fröhlich-Bum collection in Vienna, corroborates this suggestion. This fragment almost exactly mirrors the pose of the other, and is here described in print for the first time as a work of Michelangelo. The two *Cupids* were probably intended for a fountain. In the letter to his father, on 19 August 1497, Michelangelo says that he has bought *two* pieces of marble for fifty ducats a piece, one of which has turned out to be faulty. The headless *Cupid* fragment has a vein-mark running diagonally across the body.

30 Apollo, c. 1497. Marble fragment, h. 97 cm. Present whereabouts unknown. Writing in 1556, Ulisse Aldrovandi described another work in Jacopo Galli's collection as an ' Apollo, completely nude, with quiver and arrows at his side and a vase at his feet '. This cannot be identical with the *Cupid* mentioned above, and is probably to be recognized in a statue of the Bardini collection, which was sold at Christie's in London on 27 May 1902, and since lost sight of. This represents a young *Apollo*, and was probably made for Piero de' Medici, who is mentioned in Michelangelo's letter of 19 August 1497 as having commissioned a sculpture.

31-6 Bacchus, c. 1497-8. Marble, h. 203 cm. Florence, Museo Nazionale (Bargello). Carved in Rome for Jacopo Galli, this work was acquired by Francesco de' Medici in 1572 and later taken to Florence.

37-41 Pietà, 1498-9. Marble, h. 174 cm., width of base 195 cm. Rome, St Peter's. This group was carved for the French Cardinal Jean Bilhères de Lagraulas. First placed in the chapel of the kings of France in the old St Peter's, then in the chapel of Santa Maria della Febbre, and finally in its present position in the first chapel of the north aisle of the new St Peter's.

42 Virgin and Child (The Bruges Madonna), 1501. Marble, h. 128 cm. Bruges, Notre-Dame. Notwithstanding certain critical statements to the contrary, this was probably carved in Florence in 1501 and intended for the Piccolomini altar in Siena Cathedral. It was acquired by the Mouscron family of Flemish merchants in 1506.

43 St Peter and St Paul, 1501-4. Marble, h. 120 cm. each. Siena, Cathedral. The Piccolomini altar in Siena Cathedral had been designed and erected by Andrea Bregno. In 1501 Michelangelo was commissioned by Cardinal Francesco Todeschini-Piccolomini, later Pope Pius III, to carve fifteen figures for the niches of this altar in a period of three years. Once the Pope had died, in 1503, only four were delivered, *St Paul, St Peter, St Pius,* and *St Gregory,* and these were largely the work of Baccio di Montelupo.

44 David, c. 1502. Bronze, h. 33 cm. Naples, Museo Nazionale di Capodimonte. This came to the museum in 1898 from the Farnese collection. It was attributed by Venturi to Antonio Pollaiuolo and, on the occasion of an exhibition of Italian Renaissance bronzes in Amsterdam in 1961, it was attributed by Pope-Hennessy to Francesco di Giorgio Martini. While the latter suggestion places it later than Pollaiuolo, it still does not seem satisfactory in the case of this bronze, the violent nature of which could well have been suggested to Michelangelo by the nature of the material he was using. There have been other attempts to identify a model for the larger lost bronze of *David*, but these have been based for the most part on superficial resemblances. In the Naples bronze we find a similarity with the only certain means of identification: a drawing in the Louvre (Cabinet des Dessins, no. 714) which is unanimously recognized as a sketch for the bronze *David* (see illustration on page 35).

45-6 David, 1501-4. Marble, h. 434 cm. Florence, Galleria dell'Accademia. Commissioned by the cathedral administration, this work was placed beside the entrance to the Palazzo della Signoria on the recommendation of a special commission which included Leonardo da Vinci, Botticelli, Filippino Lippi, Giuliano and Antonio da Sangallo, Andrea della Robbia and Cosimo Rosselli. In 1873 it was moved to the Academy and a copy erected.

47 Virgin and Child with St John (Pitti Madonna), 1504-6.
Circular marble relief, diameter 85.5–82 cm. Florence, Museo Nazionale (Bargello). Detail. Executed for Bartolomeo Pitti, later acquired by the Guicciardini family, and in 1823 by the Bargello.

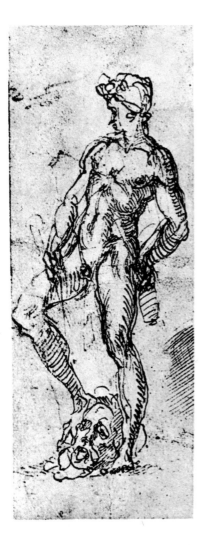

Sketch for the bronze 'David' (see p. 34).

48 Virgin and Child with St John (Taddei Madonna), 1504-6.
Circular marble relief, diameter 109 cm. London, Royal Academy.
Detail. Carved for Taddeo Taddei. At the beginning of the nineteenth
century this work was in the Wicar collection, Rome. It was bought
in 1823 by Sir George Beaumont and later given to the Royal
Academy.

49 St Matthew, c. 1506. Marble, h. 271 cm. Florence, Galleria
dell'Accademia. Statues of the twelve apostles were commissioned
for Florence Cathedral in April 1503, but the contract was cancelled
in December 1505. In the summer of 1506 Michelangelo was
working on an apostle which was probably the present work. It
was moved from the Opera del Duomo to the Academy in 1834.

50 Dying Captive, c. 1513. Marble, h. 229 cm. Paris, Louvre. See
note to *pl. 51.*

51 Heroic Captive, c. 1513. Marble, h. 215 cm. Paris, Louvre.
These are the first two statues made for the tomb of Julius II,
probably about 1513. In 1542 Michelangelo decided to replace them
with other sculptures, and two years later he gave them to Roberto
Strozzi who was in exile at Lyons. After various adventures they
arrived in their present situation.

52-3 Moses, 1512-16. Marble, h. 235 cm. Rome, San Pietro in
Vincoli. Originally executed for the second project for the tomb of
Julius II, it occupies the central position in the version finally
completed.

54 Bearded Captive, 1516-19. Marble, h. 263 cm. Florence, Gal-
leria dell'Accademia. Detail. See note to *pl. 57.*

55 Youthful Captive, 1516-19. Marble, h. 256 cm. Florence, Gal-
leria dell'Accademia. Detail. See note to *pl. 57.*

56 Awakening Captive, 1516-19. Marble, h. 267 cm. Florence,
Galleria dell'Accademia. Detail. See note to *pl. 57.*

57 Atlas, 1516-19. Marble, h. 277 cm. Florence, Galleria dell'Ac-
cademia. Detail. Michelangelo probably carved these figures between
the signing of the third contract for the tomb of Julius II in July
1516 and the end of 1519 when he began work on the Medici chapel.
Their dynamism would not seem appropriate to the later period to
which they have often been attributed. The figures remained in the
studio in the Via Mozza until Michelangelo's death, were given by
his nephew to Duke Cosimo, and placed in Buontalenti's grotto in the
Boboli Gardens, where their unfinished roughness was well adapted
to the romantic concept of the grotto. They were removed in 1908
and placed in the Academy.

58 The Risen Christ, 1519-20. Marble, h. 205 cm. Rome, Santa Maria sopra Minerva. Detail. A first version of this statue, ordered in 1514, was left half-finished and is now lost. This second version was executed in Florence and sent to Rome, where it was completed by assistants.

59 Victory, begun before 1523. Marble, h. 261 cm. Florence, Palazzo Vecchio. Detail. Carved for the monument to Julius II, though some would doubt this. The date is also disputed; some suggest 1505-6, others that it is contemporary with the *Captives* of the Louvre, or even with those of the Academy. Because of stylistic similarities with the sculptures of the Medici chapel, the idea has prevailed that it is contemporary with them, but this still leaves various possible dates: either 1524, or between 1527 and 1534, or after the siege of Florence, *i.e.* in 1532-4. In view of the weakening, after 1523, of the artist's resolution to complete the tomb of Julius II, it was probably begun before then. But it may be that the statue, roughed out before 1523, was later developed for another destination. The theme of *Victory* might have suited a project for sculptures to celebrate the Florentine war, and this would explain its similarity with the sculptures of the Medici chapel. The likeness of the face to that of Tommaso Cavalieri, whom he met in 1532, would suggest that the head was finished *c.* 1532-4.

60 Night (La Notte), 1526 - c. 1534. Marble, l. 194 cm. Florence, San Lorenzo. See note to *pl. 64.*

61 Day (Il Giorno), 1526 - c. 1534. Marble, l. 185 cm. Florence, San Lorenzo. See note to *pl. 64.*

62-3 Dawn (L'Aurora), 1526 - c. 1534. Marble, l. 203 cm. Florence, San Lorenzo. See note to *pl. 64.*

64 Dusk (Il Crepuscolo), 1526 - c. 1534. Marble, l. 195 cm. Florence, San Lorenzo. These statues for the Medici chapel were begun in 1526. It is difficult to say when they were finished, but it is was at any rate before the end of 1534.

65 Apollo-David, c. 1526 - c. 1530. Marble, h. 146 cm. Florence, Museo Nazionale (Bargello). This figure was probably begun for the Medici tombs, but was further developed after the siege of 1530, and dedicated to the representative of the Medici pope, Baccio Valori. The title *Apollo* is probably an allusion to the restoration of the Medici, but the figure is also like a *David*, and this would give it a latent allusion to republican liberty. From the Medici collection the sculpture was transferred to the Boboli Gardens; it was later moved to the Uffizi, and finally to the Bargello.

66-7 River God, c. 1524. Clay bound with wool over wood, l. 180 cm. Florence, Casa Buonarroti. Modelled for one of the Medici tombs. It belonged to Cosimo I who gave it to Bartolomeo Ammannati, from whom it passed to the Academy in 1583.

68 Lorenzo de' Medici, Duke of Urbino, begun 1524. Marble, h. 178 cm. Florence, San Lorenzo. See note to *pl. 69.*

69 Giuliano de' Medici, Duke of Nemours, begun 1526. Marble, h. 173 cm. Florence, San Lorenzo. Both these statues were completed by Giovannangelo Montorsoli.

70-1 Virgin and Child (Medici Madonna), begun c. 1521. Marble, h. 226 cm. Florence, San Lorenzo. Begun at an early stage of the Chapel works, it shows signs of later reworking and remains unfinished.

72-5 Florentine Pietà, begun c. 1535. Marble, h. 226 cm. Florence, Cathedral (Santa Maria del Fiore). Vasari mentions it in a general way in his first edition, and Condivi records it as still unfinished but intended for the artist's own tomb. In his second edition, Vasari reports that the artist had wanted to destroy it in a moment of dissatisfaction. The figure of the Magdalen was finished by Tiberio Calcagni. In 1561 Michelangelo gave the group to Francesco Bandini. Cosimo I had it brought to Florence, where it was kept for a while in the crypt of San Lorenzo, then placed at the back of the high altar in the Cathedral. Since 1933 it has stood in a side chapel of the choir. It may have been begun about 1534-5 for a precise situation such as a tomb for one of the Medici popes, Leo X or Clement VII. The *Palestrina Pietà*, at one time in the Barberini Chapel in Palestrina, and now in the Academy in Florence, was for long attributed to Michelangelo. It was probably also intended for a tomb, but is more likely to be the work of Francesco Sangallo, for which reason it is not reproduced here.

76 Brutus, after 1537. Marble, h. 95 cm. including base. Florence, Museo Nazionale (Bargello). Executed for the Cardinal Niccolò Ridolfi, in honour of Lorenzino de' Medici who assassinated the tyrant Duke Alessandro de' Medici in 1537. The drapery was finished by Tiberio Calcagni.

77 The Contemplative Life (Rachel), begun 1542. Marble, h. 197 cm. Rome, San Pietro in Vincoli. See note to *pl. 78.*

78 The Active Life (Leah), begun 1542. Marble, h. 209 cm. Rome, San Pietro in Vincoli. Executed with the collaboration of Raffaello da Montelupo, these two figures were the last to be added to the final project for the tomb of Julius II, erected in 1545.

79-80 Rondanini Pietà, begun before 1555. Marble, h. 191 cm. Milan, Museo Civico (Castello Sforzesco). Vasari mentions it in his

second edition, recording that Michelangelo worked on it after he had damaged the *Florentine Pietà* (before 1555). He returned to it at intervals, making radical changes in its composition, and was still working on it six days before his death. From a record of 1652 we know that it was found half-buried in the earth in Michelangelo's Rome studio, Macello dei Corvi. It later stood in the courtyard of the Palazzo Rondanini.

The following works are not reproduced: two statues for the Piccolomini altar in Siena Cathedral – *St Pius* and *St Gregory* – the *Crouching Youth* in the Hermitage Museum, Leningrad, and a number of small sketch models.

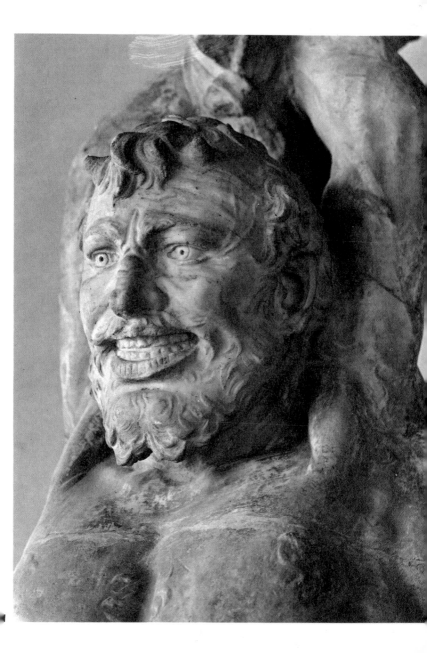

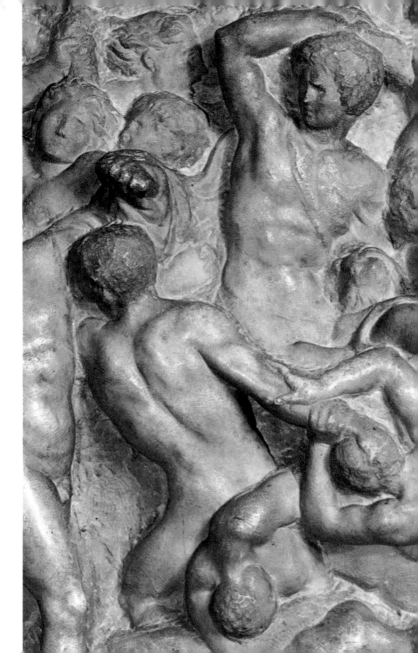

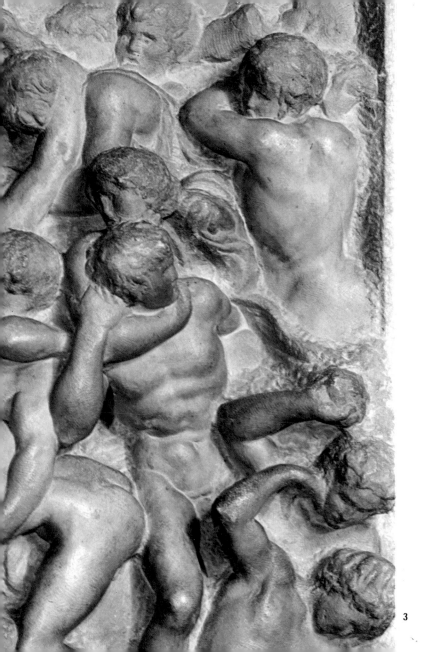

3

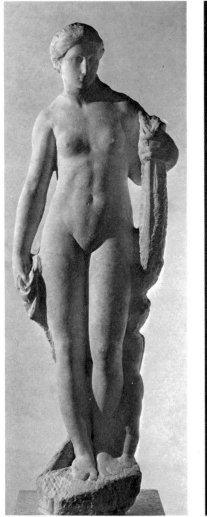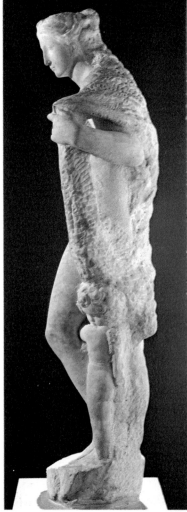

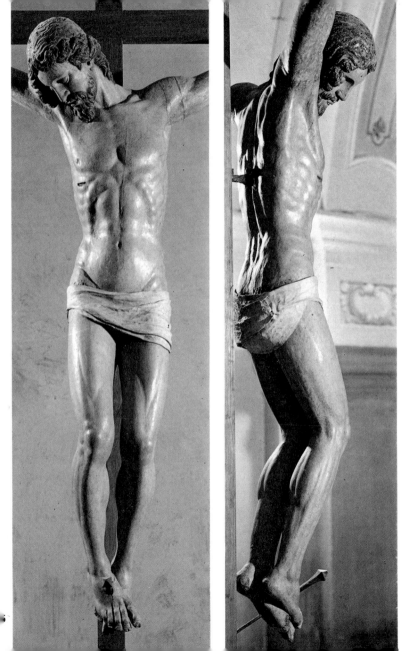

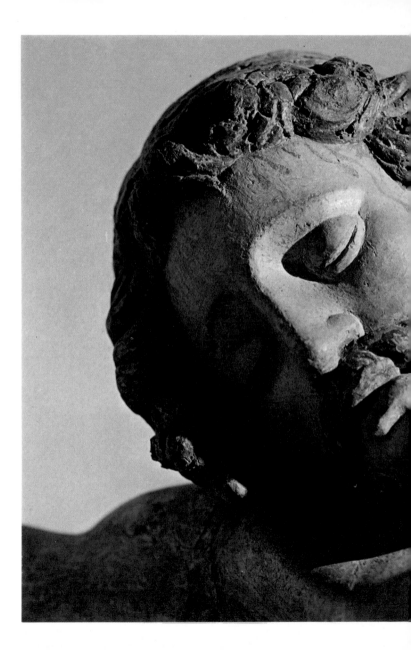

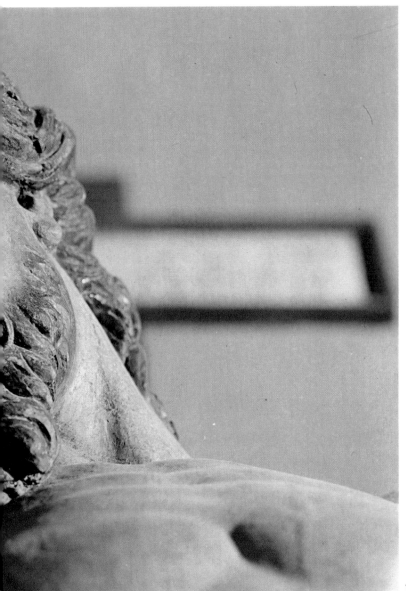

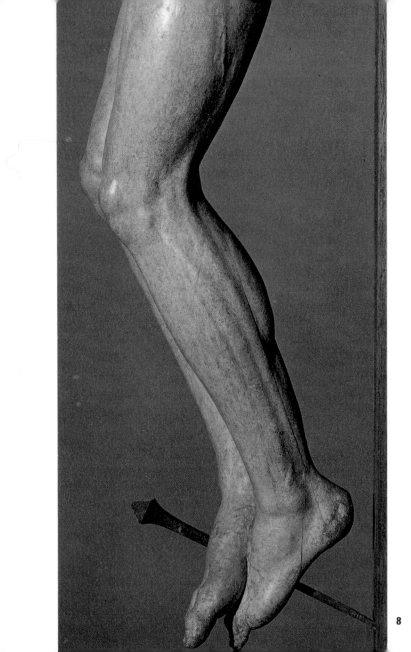

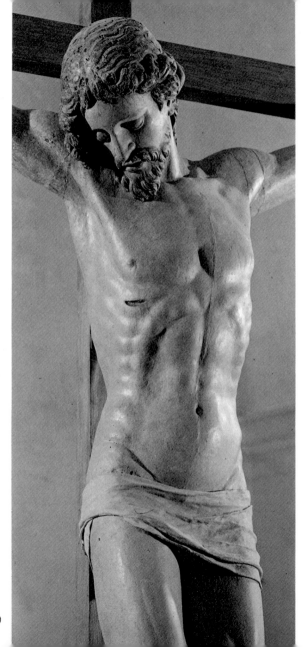

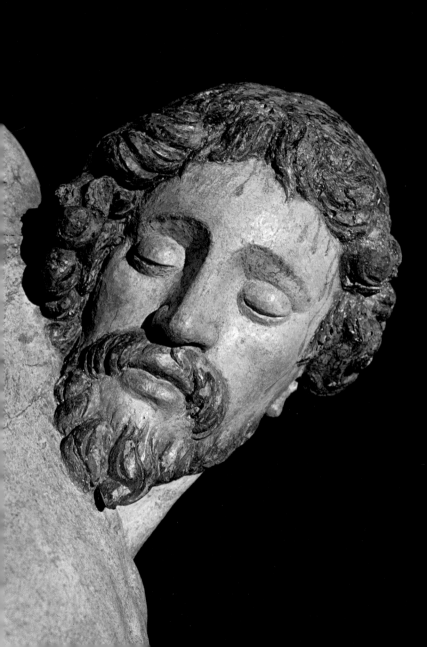

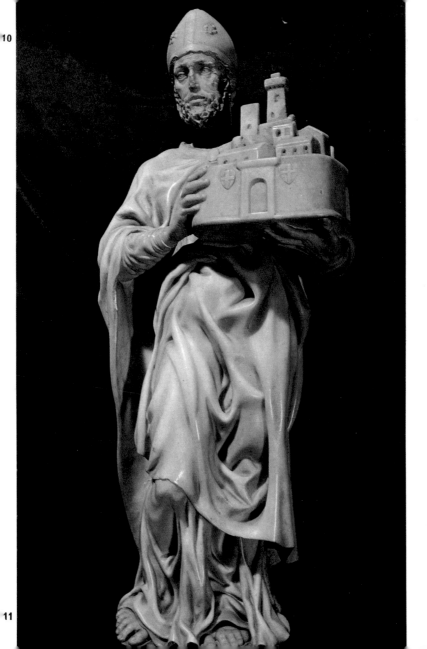

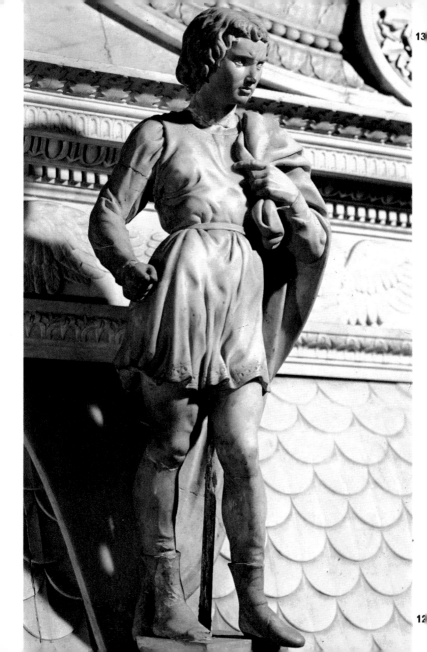

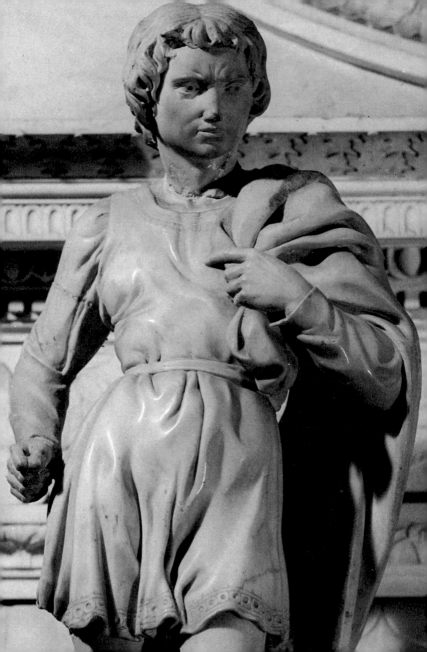

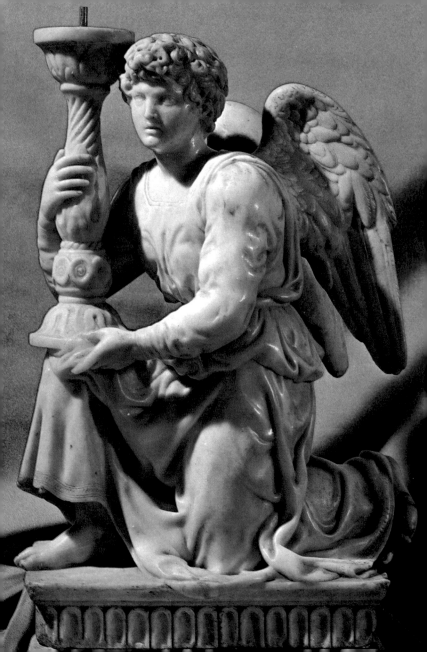

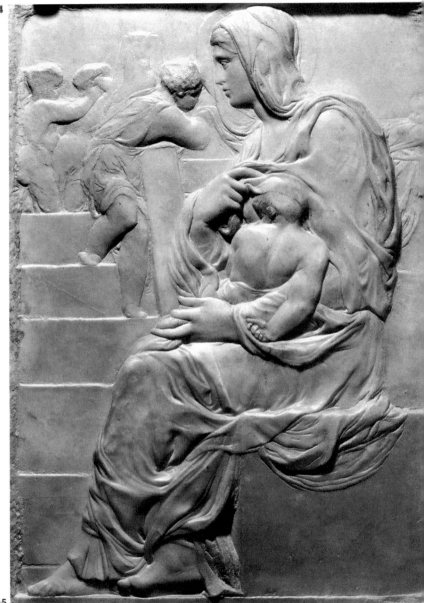

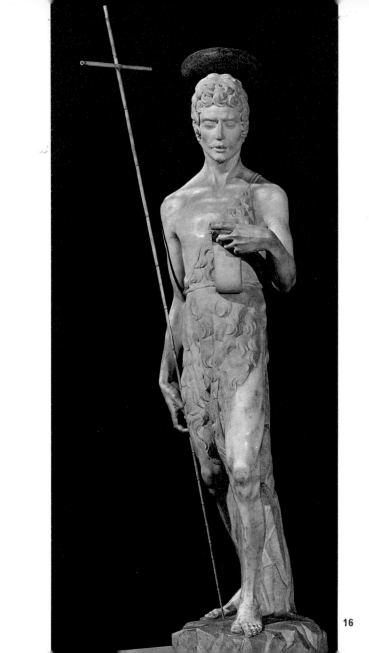

16

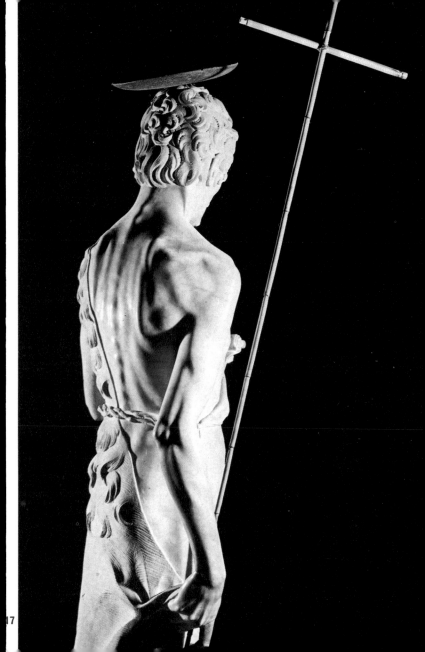

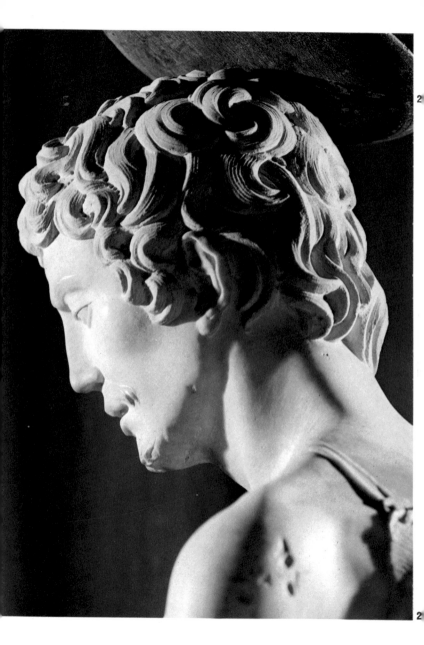

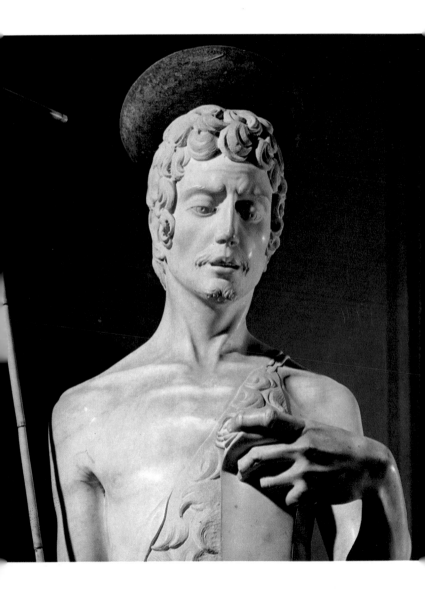

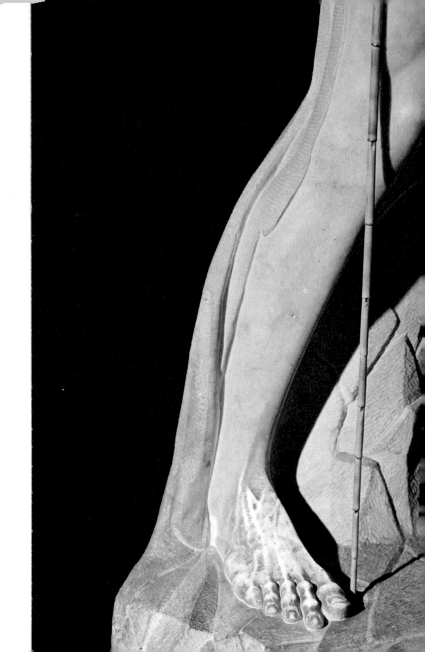

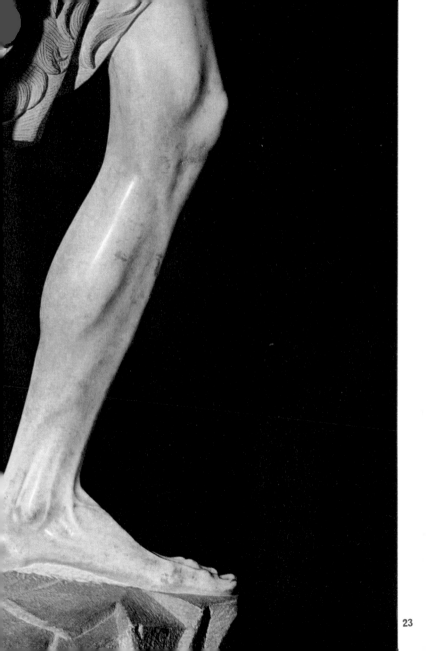

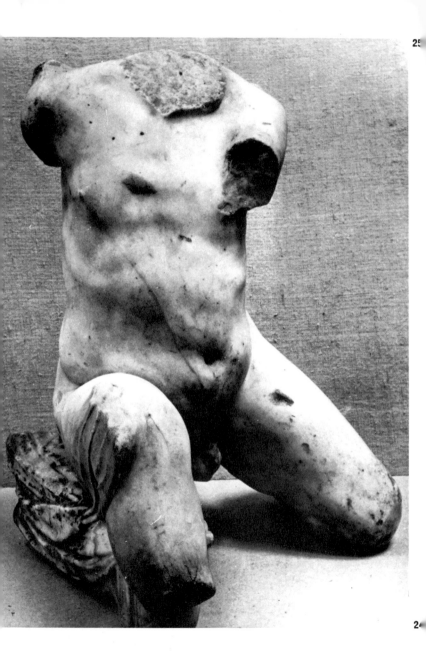

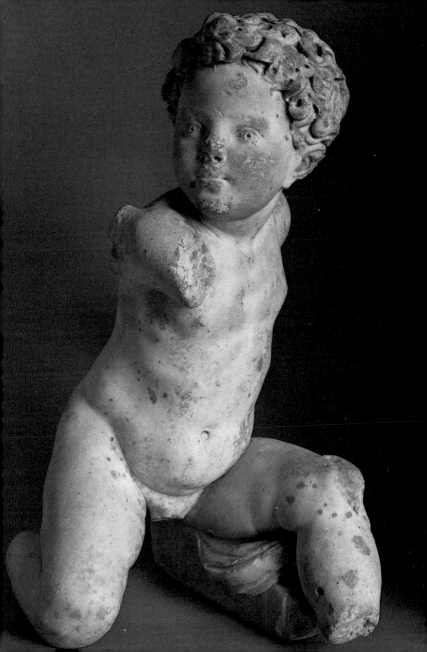

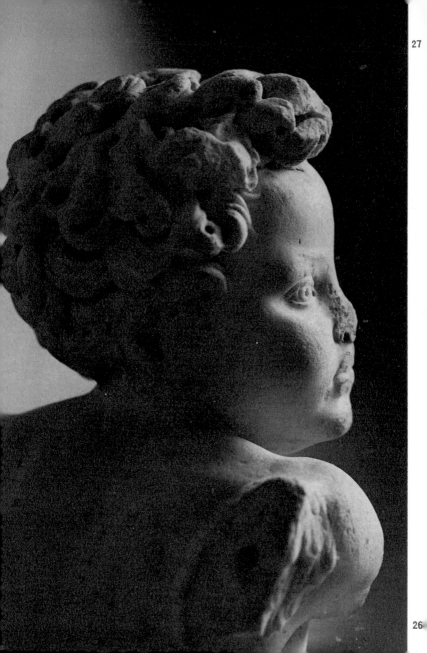

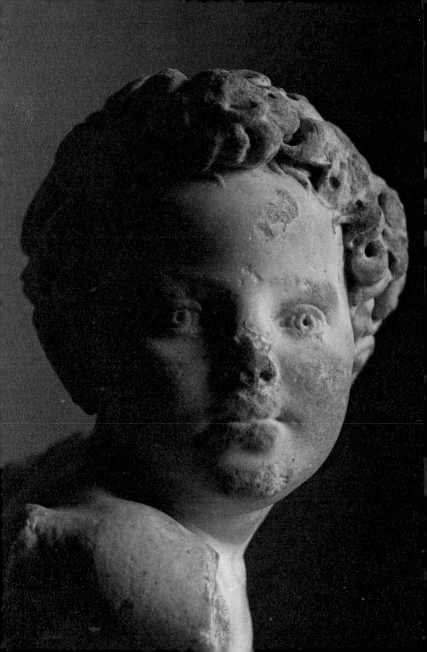

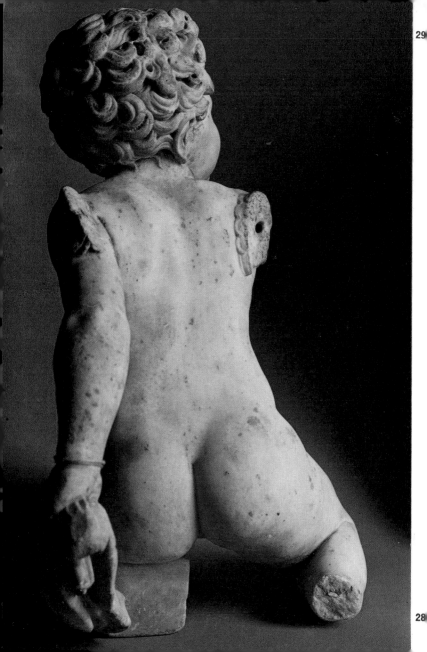

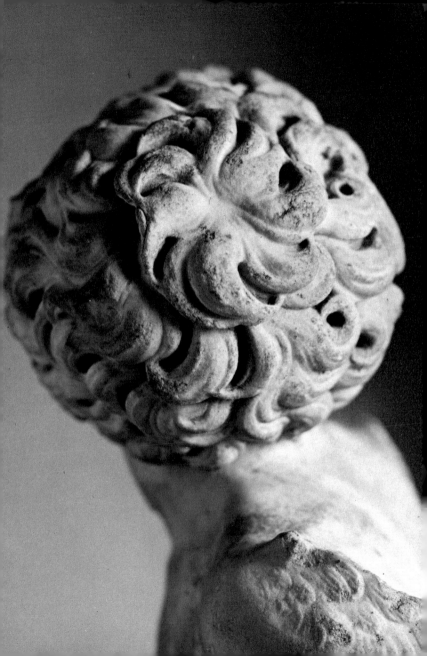

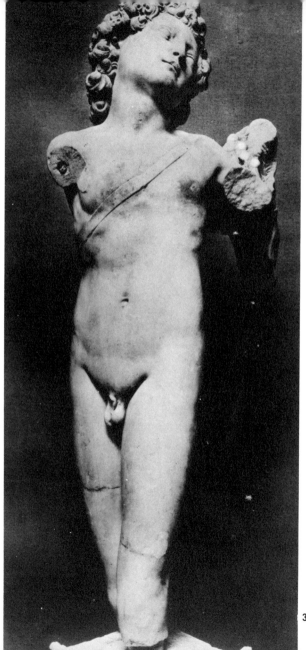

30

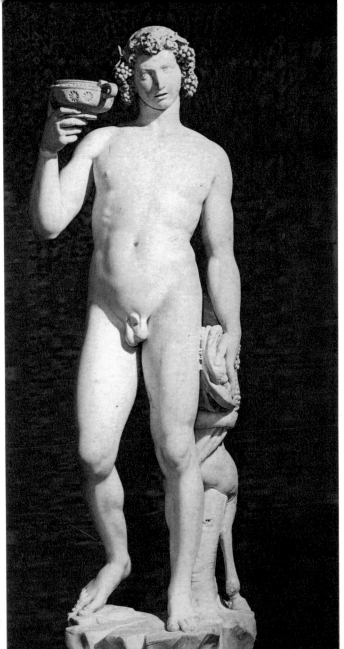

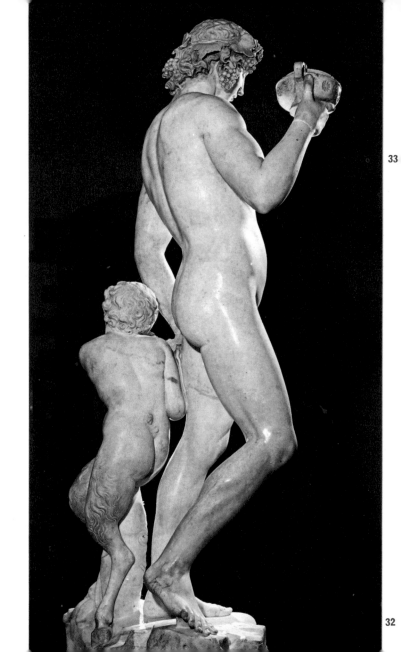

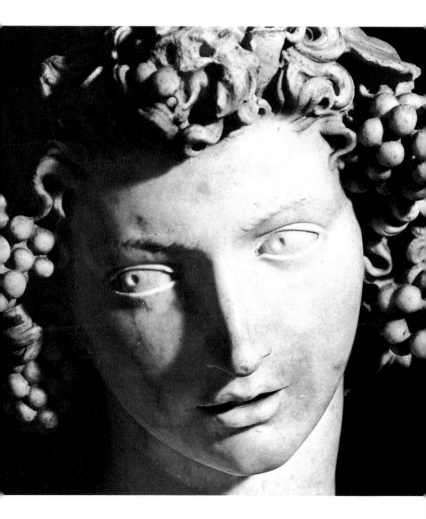

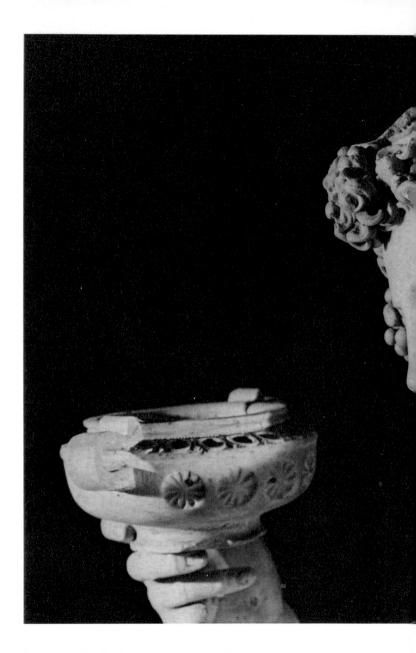

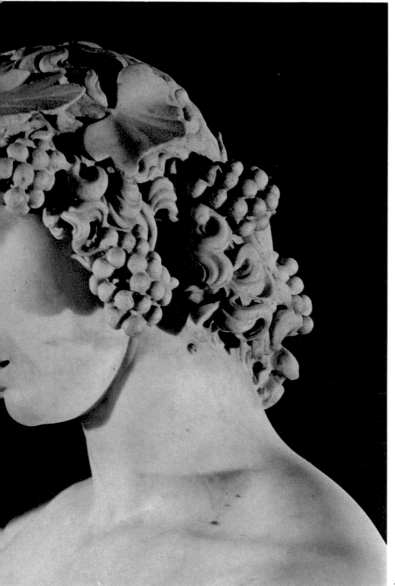

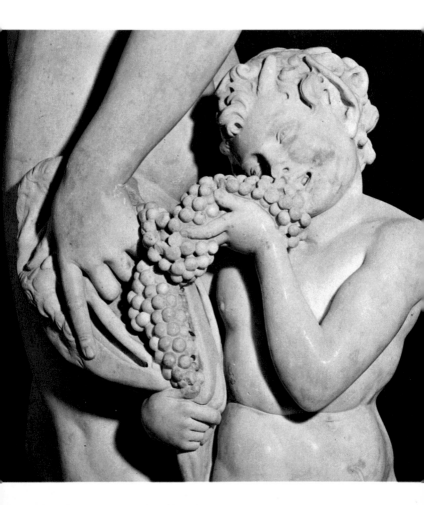

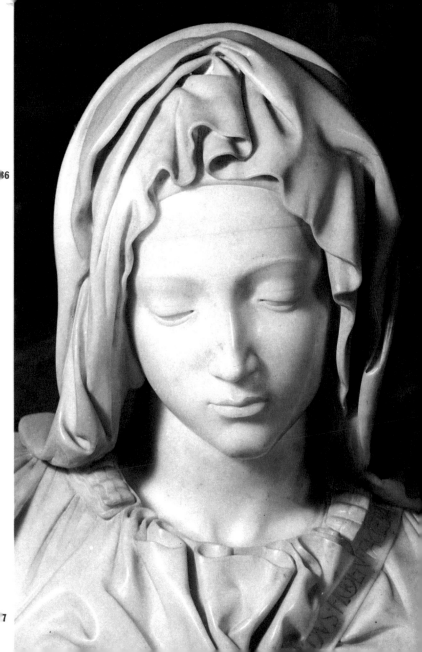

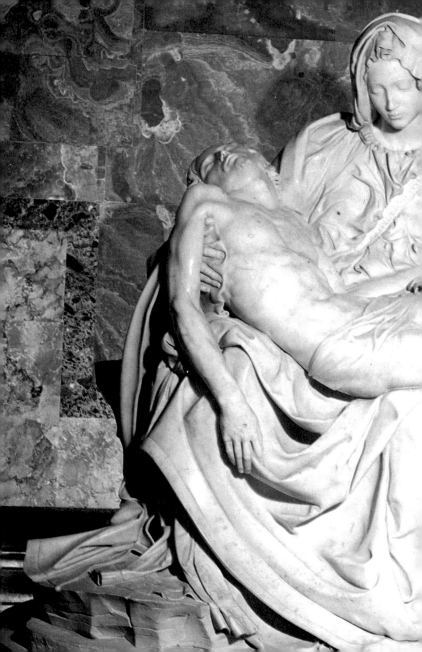

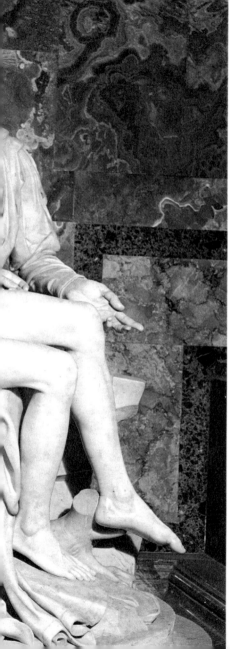

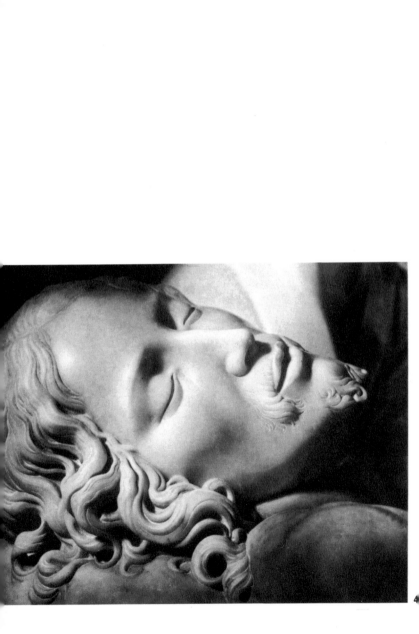

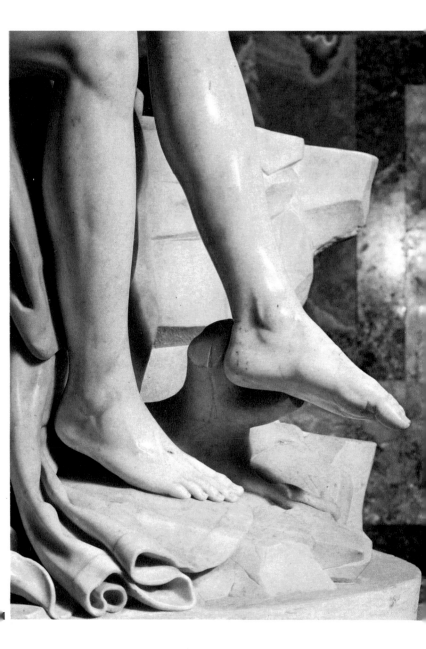

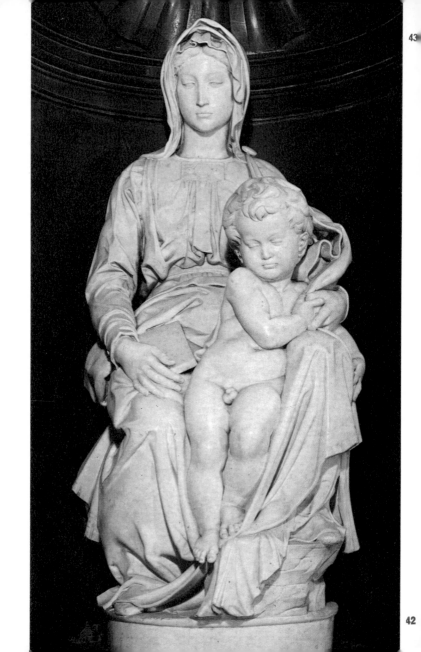

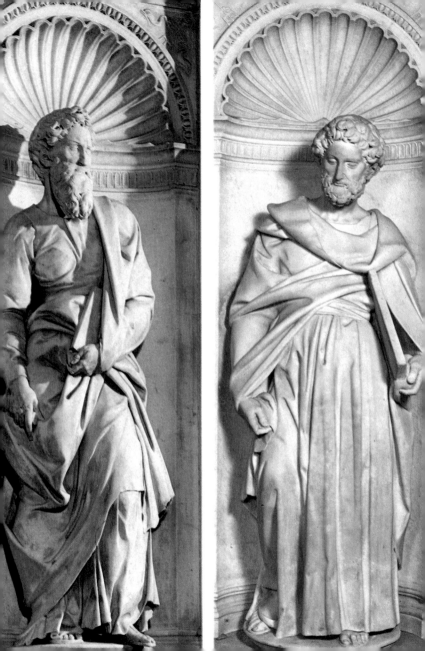

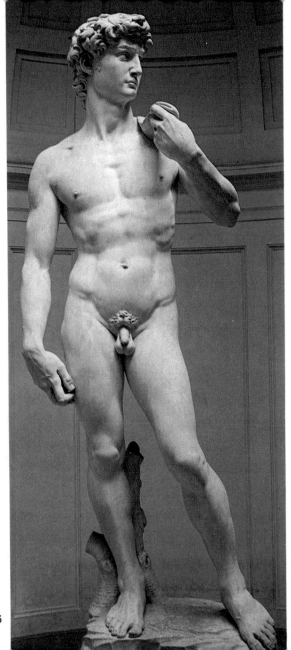

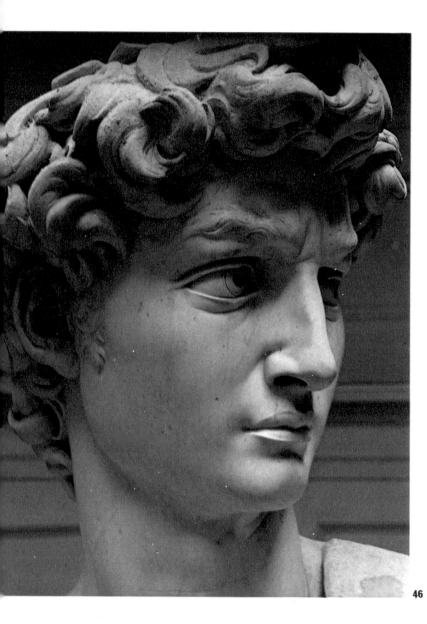

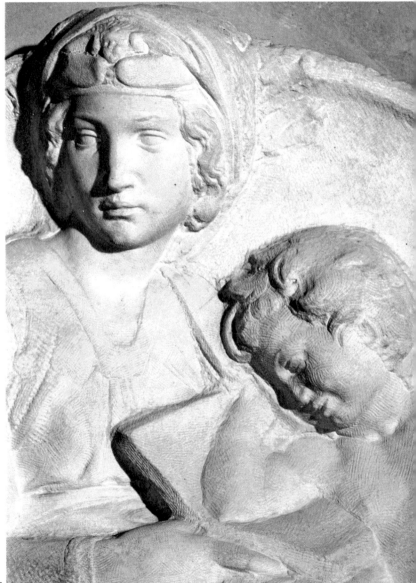

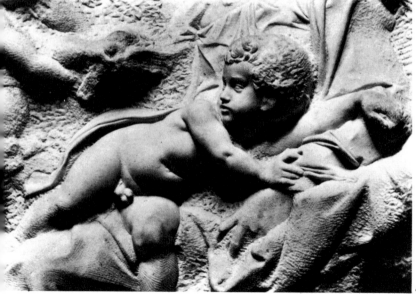

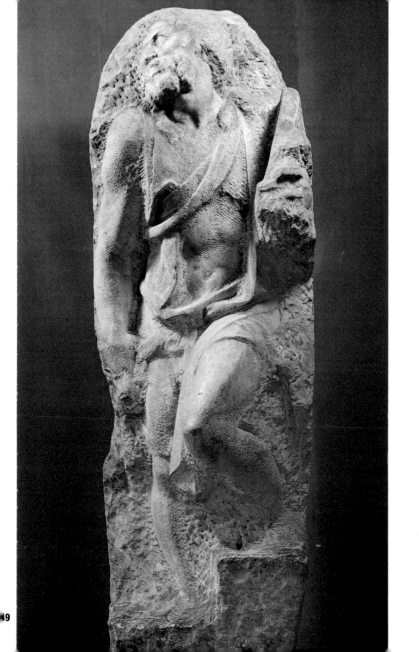

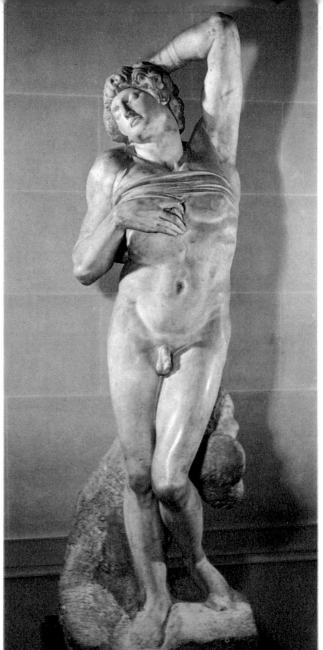

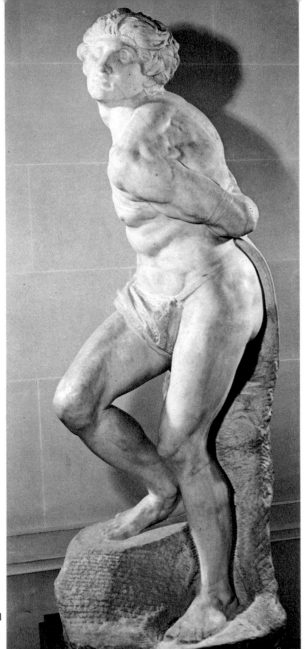

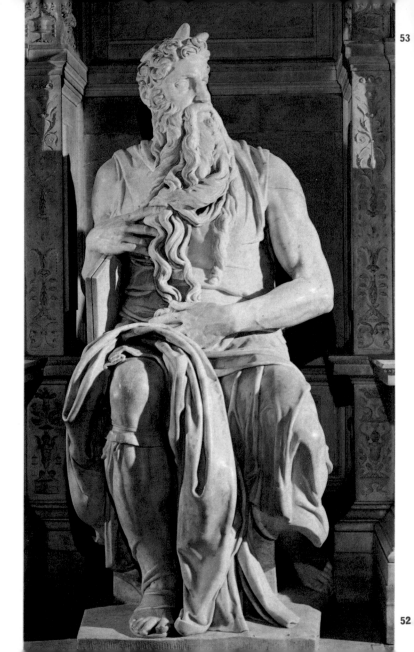

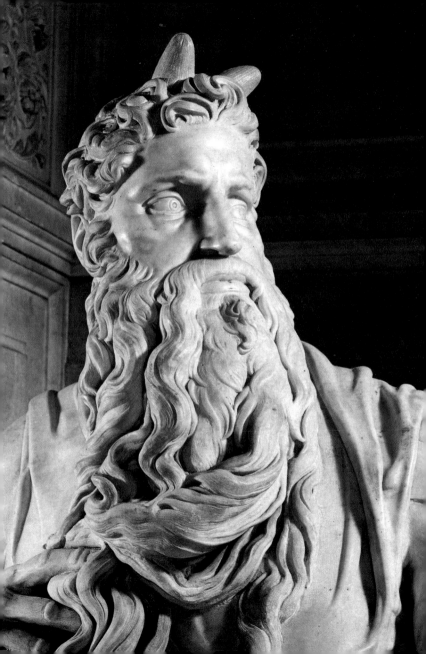

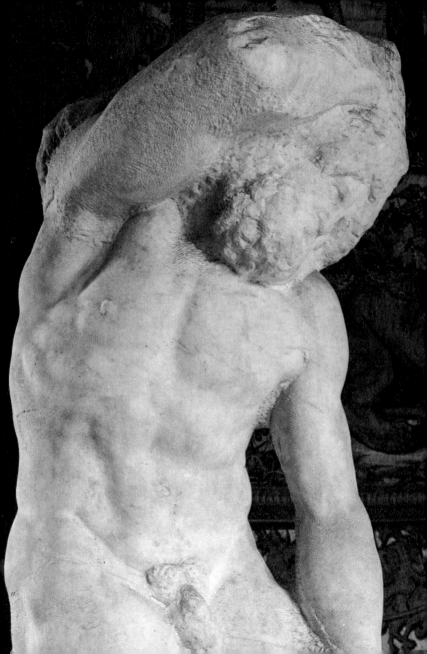

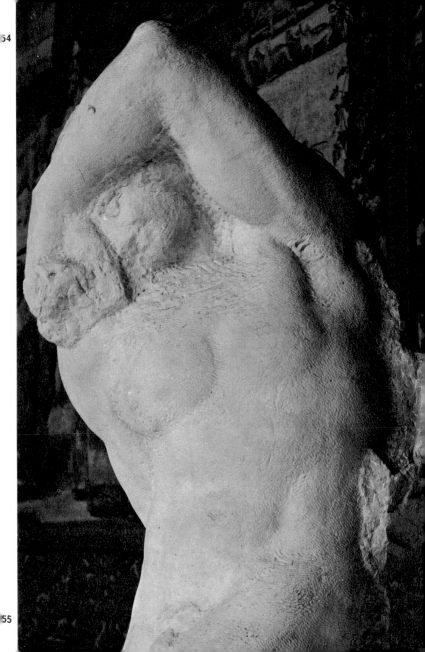

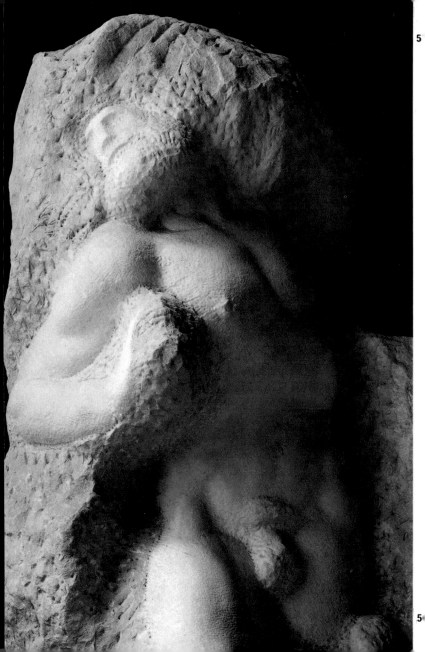

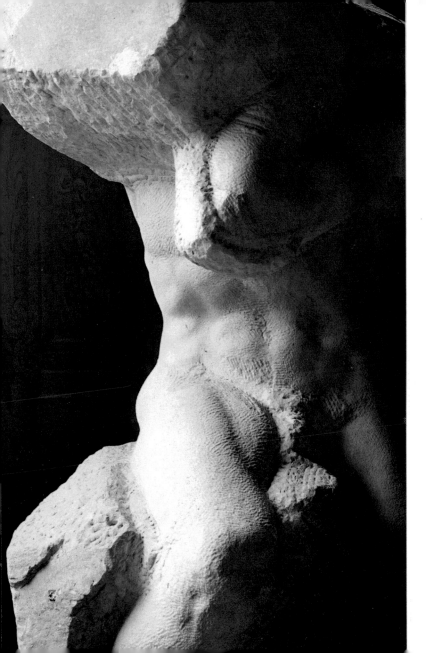

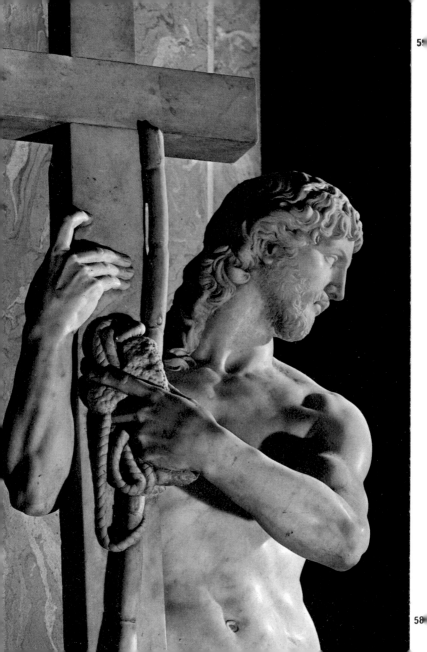

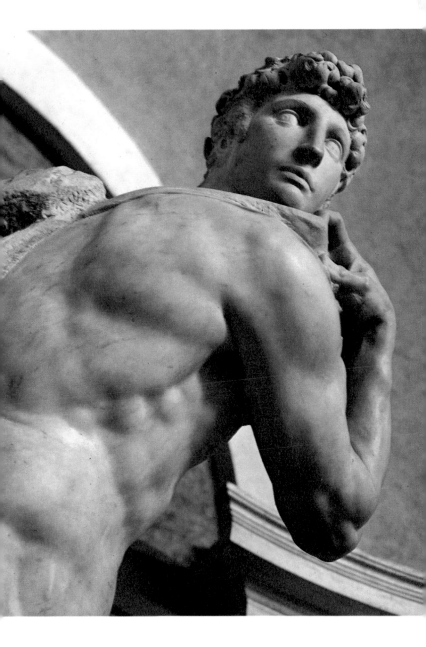

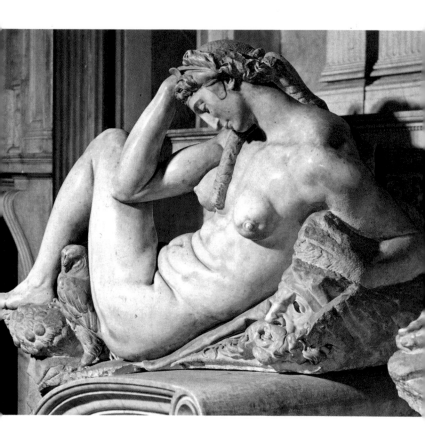

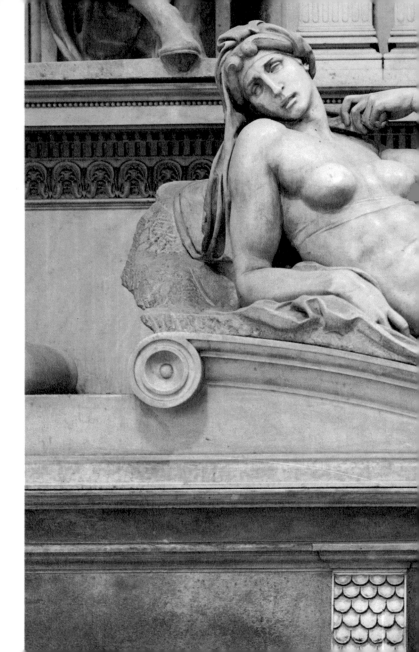

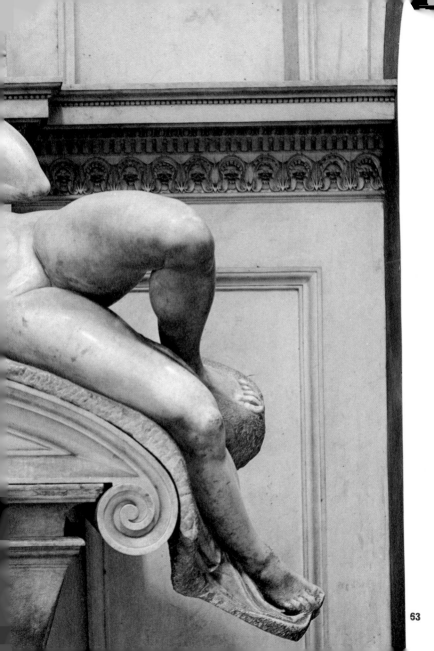

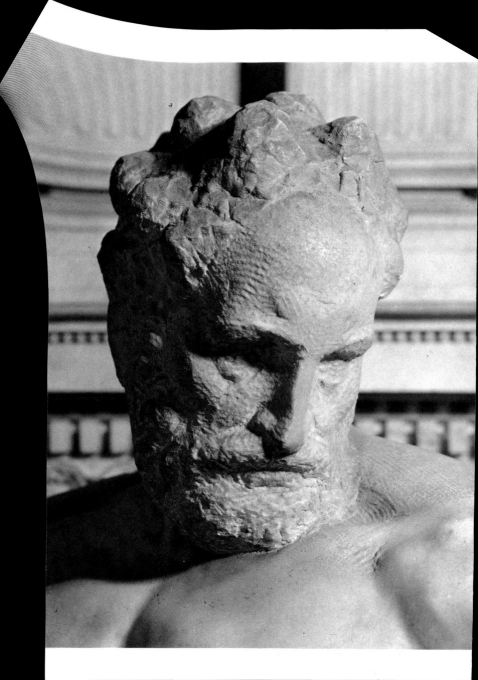

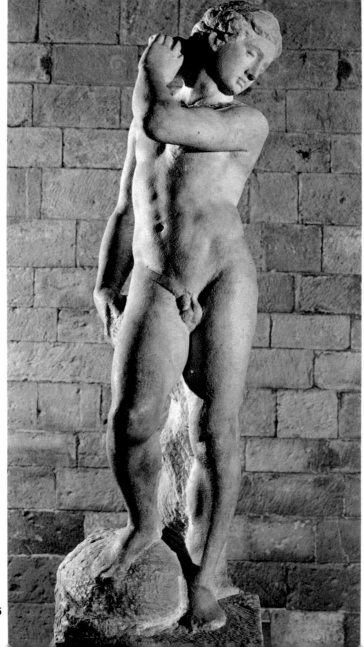

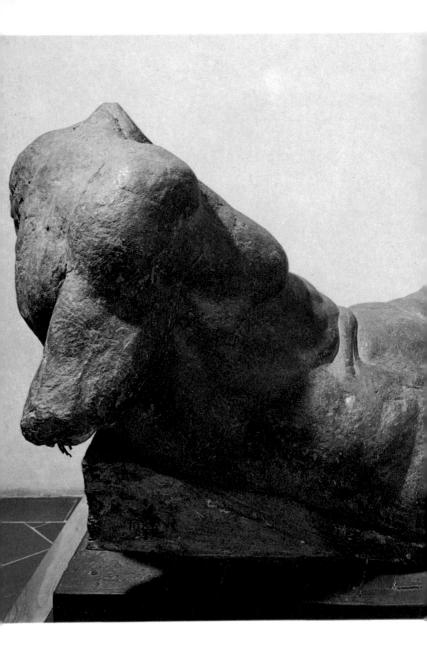

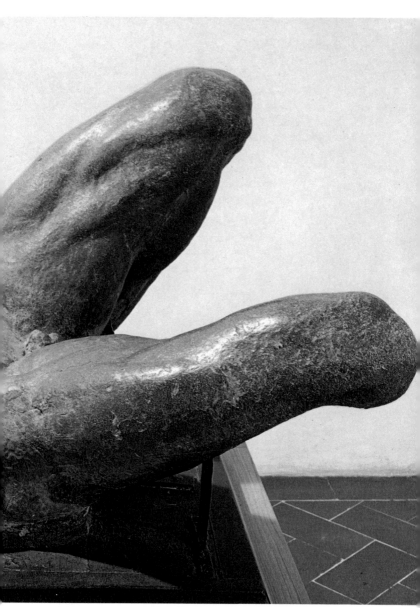

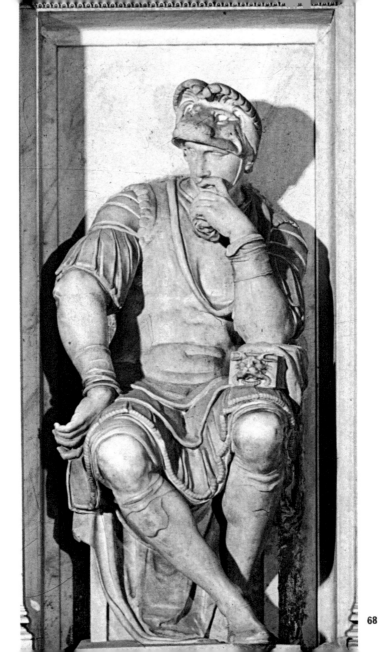

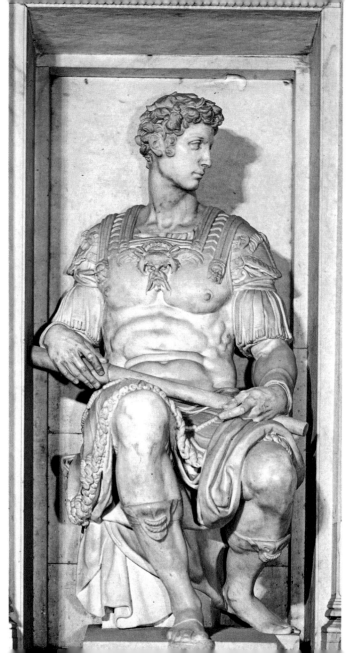

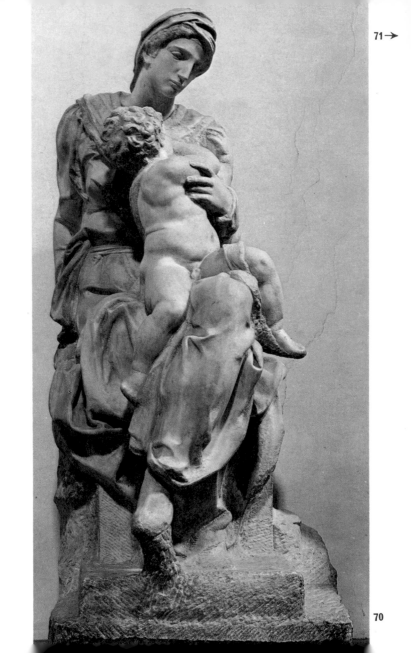

71→

70

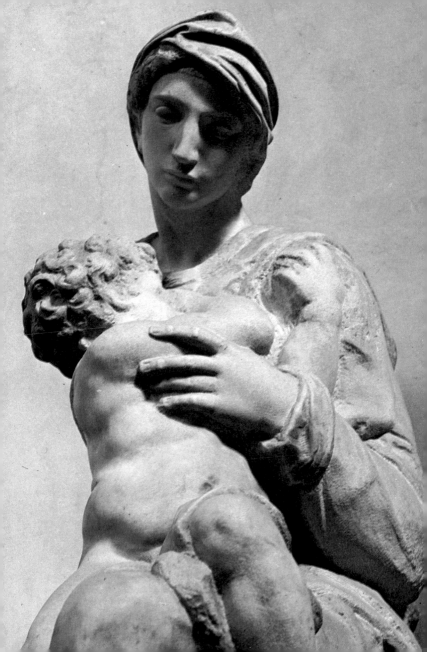

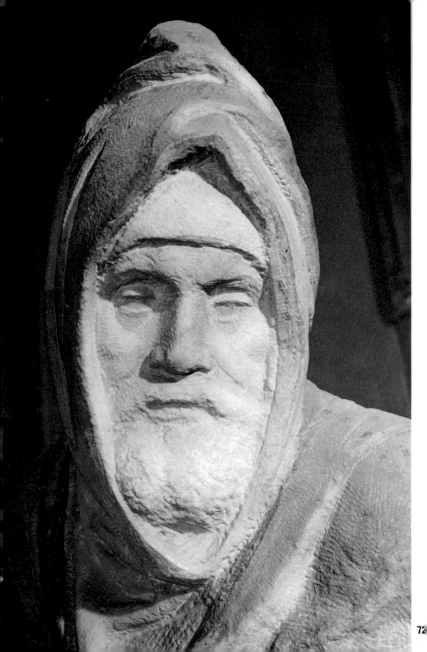

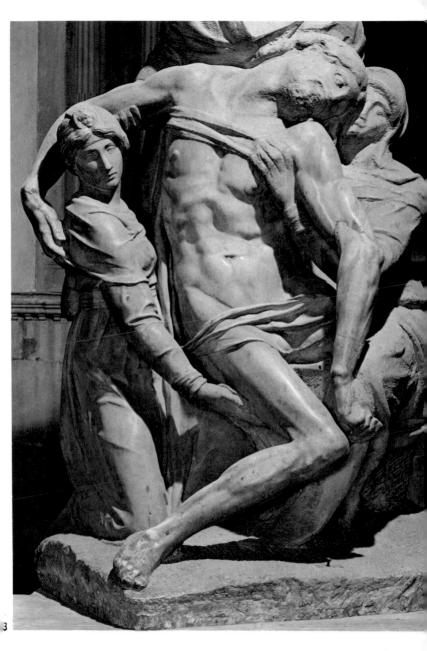

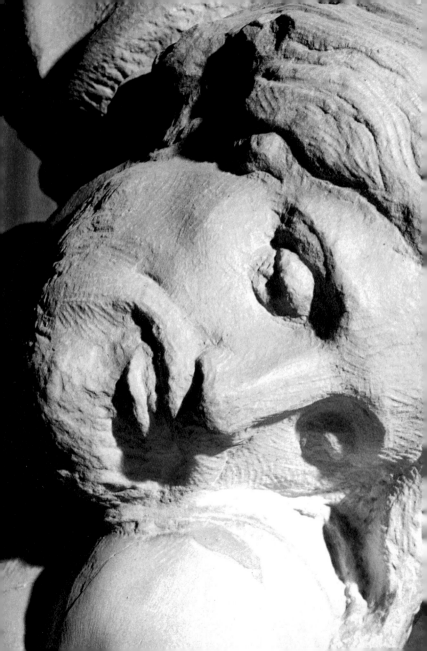

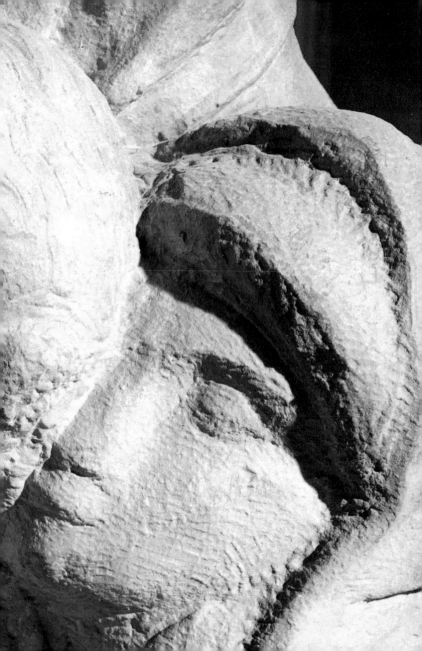

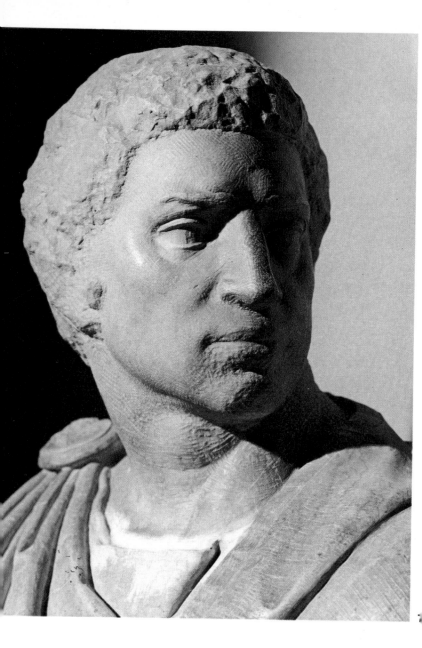

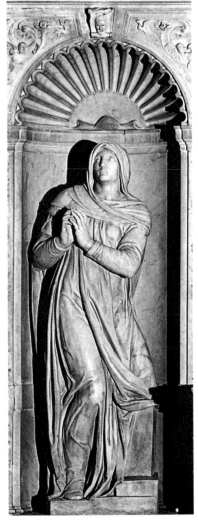

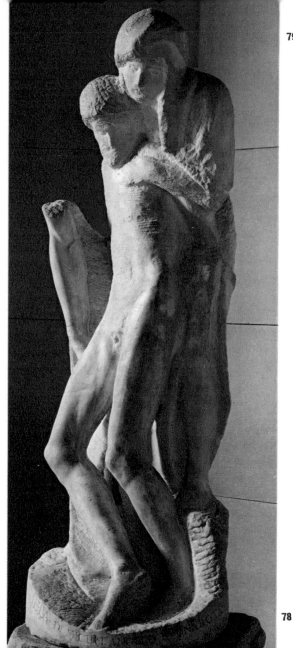

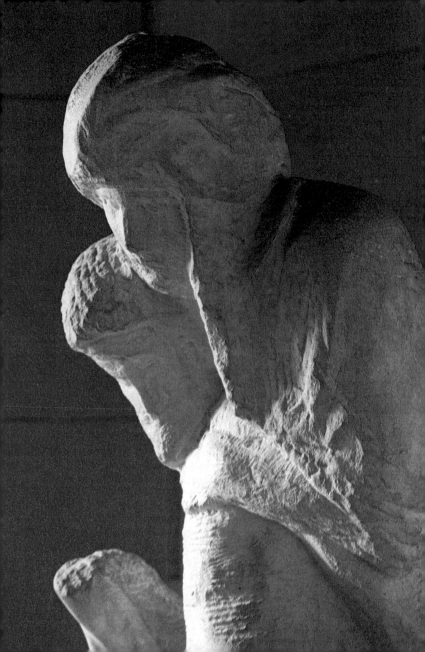

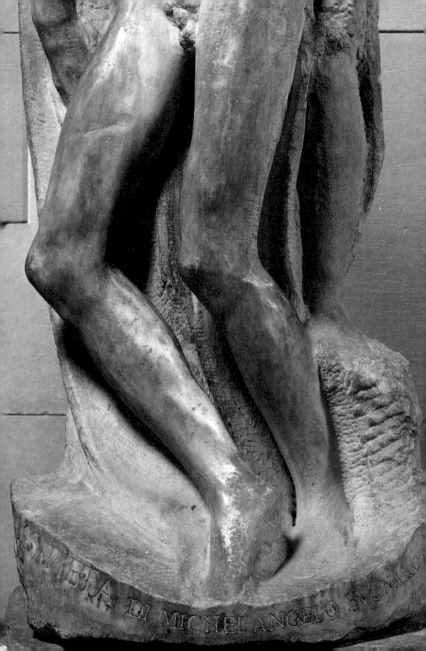